Printed in the United States of America.

New York, New York

www.natalienascenzi.com

Cover painting by Grant McGrath
"Natalie" Acrylic on canvas.

Paintings and artwork
Copyright © 2020 by Grant McGrath
*Self Portrait 01: The Puzzle Factory, Self Portrait 08: I am Red, Spring,
Portraiting, Self Portrait 05: Hold it Together, In Bloom, Release, All
the Feels, Union Square, Friday, Self Portrait Seven, Sand in the Wind,
Watching Time, The Curious Case of Rectangle Face, Self Portrait 04: Rent,
Sonder on Park Ave, Self Portrait Three*

Book layout and design by Nicolle Diiorio

ISBN: 978-0-578-77766-5

Library of Congress Control Number: 2020922089

Never lose hope.

Sometimes we bump into angels

They shake us awake and rattle our souls

Help us to settle the chaos surrounding

When the world seems to swallow us whole.

This book is dedicated to my mom:

Anita Nascenzi

Thank you for everything

"The most extraordinary story continues!"

"Hi"

The
Aftermath of Unrest

Natalie Nascenzi

Artwork by Grant McGrath
Design by Nicolle Diiorio

MENTALITY DUALITY REALITY MENTALITY DUALITY REALITY
MENTALITY DUALITY REALITY MENTALITY DUALITY REALITY
MENTALITY DUALITY REALITY MENTALITY DUALITY REALITY
MENTALITY DUALITY REALITY MENTALITY DUALITY REALITY
MENTALITY DUALITY REALITY MENTALITY DUALITY REALITY
MENTALITY DUALITY REALITY MENTALITY DUALITY REALITY
MENTALITY DUALITY REALITY MENTALITY DUALITY REALITY
MENTALITY DUALITY REALITY MENTALITY DUALITY REALITY
MENTALITY DUALITY REALITY MENTALITY DUALITY REALITY
MENTALITY DUALITY REALITY MENTALITY DUALITY REALITY
MENTALITY DUALITY REALITY MENTALITY DUALITY REALITY
MENTALITY DUALITY REALITY MENTALITY DUALITY REALITY
MENTALITY DUALITY REALITY MENTALITY DUALITY REALITY
MENTALITY DUALITY REALITY MENTALITY DUALITY REALITY
MENTALITY DUALITY REALITY MENTALITY DUALITY REALITY
MENTALITY DUALITY REALITY MENTALITY DUALITY REALITY
MENTALITY DUALITY REALITY MENTALITY DUALITY REALITY
MENTALITY DUALITY REALITY MENTALITY DUALITY REALITY
MENTALITY DUALITY REALITY MENTALITY DUALITY REALITY
MENTALITY DUALITY REALITY MENTALITY DUALITY REALITY
MENTALITY DUALITY REALITY MENTALITY DUALITY REALITY
MENTALITY DUALITY REALITY MENTALITY DUALITY REALITY
MENTALITY DUALITY REALITY MENTALITY DUALITY REALITY
MENTALITY DUALITY REALITY MENTALITY DUALITY REALITY
MENTALITY DUALITY REALITY MENTALITY DUALITY REALITY
MENTALITY DUALITY REALITY MENTALITY DUALITY REALITY
MENTALITY DUALITY REALITY MENTALITY DUALITY REALITY
MENTALITY DUALITY REALITY MENTALITY DUALITY REALITY
MENTALITY DUALITY REALITY MENTALITY DUALITY REALITY
MENTALITY DUALITY REALITY MENTALITY DUALITY REALITY
MENTALITY DUALITY REALITY MENTALITY DUALITY REALITY
MENTALITY DUALITY REALITY MENTALITY DUALITY REALITY
MENTALITY DUALITY REALITY MENTALITY DUALITY REALITY
MENTALITY DUALITY REALITY MENTALITY DUALITY REALITY
MENTALITY DUALITY REALITY MENTALITY DUALITY REALITY
MENTALITY DUALITY REALITY MENTALITY DUALITY REALITY

MENTALITY DUALITY REALITY MENTALITY DUALITY REALITY
MENTALITY DUALITY REALITY MENTALITY DUALITY REALITY
MENTALITY DUALITY REALITY MENTALITY DUALITY REALITY
MENTALITY DUALITY REALITY MENTALITY DUALITY REALITY
MENTALITY DUALITY REALITY MENTALITY DUALITY REALITY
MENTALITY DUALITY REALITY MENTALITY DUALITY REALITY
MENTALITY DUALITY REALITY MENTALITY DUALITY REALITY
MENTALITY DUALITY REALITY MENTALITY DUALITY REALITY
MENTALITY DUALITY REALITY MENTALITY DUALITY REALITY
MENTALITY DUALITY REALITY MENTALITY DUALITY REALITY
MENTALITY DUALITY REALITY MENTALITY DUALITY REALITY
MENTALITY DUALITY REALITY MENTALITY DUALITY REALITY
MENTALITY DUALITY REALITY MENTALITY DUALITY REALITY
MENTALITY DUALITY REALITY MENTALITY DUALITY REALITY
MENTALITY DUALITY REALITY MENTALITY DUALITY REALITY
MENTALITY DUALITY REALITY MENTALITY DUALITY REALITY
MENTALITY DUALITY REALITY MENTALITY DUALITY REALITY
MENTALITY DUALITY REALITY MENTALITY DUALITY REALITY
MENTALITY DUALITY REALITY MENTALITY DUALITY REALITY
MENTALITY DUALITY REALITY MENTALITY DUALITY REALITY
MENTALITY DUALITY REALITY MENTALITY DUALITY REALITY
MENTALITY DUALITY REALITY MENTALITY DUALITY REALITY
MENTALITY DUALITY REALITY MENTALITY DUALITY REALITY
MENTALITY DUALITY REALITY MENTALITY DUALITY REALITY
MENTALITY DUALITY REALITY MENTALITY DUALITY REALITY
MENTALITY DUALITY REALITY MENTALITY DUALITY REALITY
MENTALITY DUALITY REALITY MENTALITY DUALITY REALITY
MENTALITY DUALITY REALITY MENTALITY DUALITY REALITY
MENTALITY DUALITY REALITY MENTALITY DUALITY REALITY
MENTALITY DUALITY REALITY MENTALITY DUALITY REALITY
MENTALITY DUALITY REALITY MENTALITY DUALITY REALITY
MENTALITY DUALITY REALITY MENTALITY DUALITY REALITY
MENTALITY DUALITY REALITY MENTALITY DUALITY REALITY
MENTALITY DUALITY REALITY MENTALITY DUALITY REALITY
MENTALITY DUALITY REALITY MENTALITY DUALITY REALITY
MENTALITY DUALITY REALITY MENTALITY DUALITY REALITY
MENTALITY DUALITY REALITY MENTALITY DUALITY REALITY

Picture this...

You're a boxer and your mind is the ring.

Every round you have to give it your all in order to win and become the champion of your thoughts. Every round you have a different opponent.

Sometimes, it's fear, doubt, or sadness. Other times, it can be loneliness, anger or longing. Nonetheless, any demon of the mind you face becomes an opponent in the ring.

But, whatever it may be—*you're ready for it.*

You're strong.

You've trained.

It's been quite the long, difficult, and exhausting journey.

But...you're ready.

You can beat them. And, you do.

Every. Single. Round.

Just when you think you've got the belt, the final bell rings and in walks a new opponent.

You walk towards the center of the ring.

You have already won the battle with every other emotion. What could possibly make you falter?

You stretch out your hand for a shake before the next fight can begin.

Your new opponent does the same.

You say, "I didn't see this coming…"

It says back, "I'm known for that...."

"…Nice to meet you…*I'm reality.*"

A new battle begins.

Hello Reader, we meet again.

…That is, if you're coming from *Out of Chaos*. If you're not, that's okay. You'll catch on! Let's start here:

What happened at the intersection of chaos and change?

Well, change certainly happened. Chaos remained constant, although, I had it under control. The story that began on a normal November morning in 2018 was only the start of a long and eventful journey. I took you with me in and out of chaos, through the battle of my mind and the triumph of my soul...*up until that particular point in time.* However, that was only the first chaotic chapter of many that would follow. One of which, you're reading *right now.*

Despite everything, I was still ravaged by anxiousness, restlessness, doubt, insecurity, and intrusive thoughts. Life was like UPS, delivering a perfect package of pure insanity that was neatly wrapped and ready to be ripped open.

"But…you came out of the chaos, Natalie! You conquered it!" For the most part—*yes*. The truth is, when it comes to the mind, the battle is never truly won. It is a war that you have continue fighting even after you emerge victorious. Every time you rise from the ashes of your internal madness, you have to be prepared for the next time the fire ignites. The key is to be one step ahead, to never give up on yourself, and to continue strengthening your armor so that you can continue to win. It's important to remember: every time the battle is won it will eventually begin again. But when it does, you will be better, smarter, and more equipped.

During the process of completing *Out of Chaos*, I immediately had my mind set on a second book. I had no idea how or when it would come together, but I had the thought—*the spark*. That's really all you need. In

the months that followed, I continued to battle my thoughts. Luckily, I had them under control because I had learned how to handle the chaos. Nonetheless, there was an endless list of emotions that I was continually pouring into poems and an even loftier list of life-changing events that started stacking up. But hey, *that's life*. So much happened and most of it I didn't see coming—*both good and bad.*

As my understanding of duality grew and as life as poet began to unfold before me, I continued writing. *The Aftermath of Unrest* was being written parallel to *Out of Chaos* because of *Out of Chaos*. That's how life works, one thing leads to another and every action has a reaction, but more on that later.

Time passed. I started performing my poetry, which opened up an entirely new can of insecurities. My negative thoughts never faltered and *neither did I*. Poetry helped. Writing gave me an odd sense of "knowing" and allowed me to access the sides of myself that I didn't know still needed healing. The sole act of moving forward, having a goal, and pushing myself to be better were the ingredients to silencing the chaos of my anxious mind. The words helped to soothe and settle my restless soul. The key, my dear Reader, **is to never give up on yourself**. At one point, I was certain that I finally had it all back together. I was chaotically balanced and at peace with the war inside my mind. Just as everything was falling beautifully into place…

Reality smacked me in the face.

Actually, it smacked us all in the face. See, most of this book is being finished in *quarantine*. I'm almost positive none of us saw this coming. The year of 2020 has already hit us with pretty much everything: the pandemic, toilet paper shortage, world on fire, tiger kings, giant killer bees, parallel universes, civil unrest, and my personal favorite—aliens! Those realities are the bigger picture problems that are happening right now in the world around us, but there are everyday realities that always find a way to shake us to the core.

Life is really good at throwing curve balls, knocking us off our tracks, and testing our mentality. It loves to smack us awake and rough us up. That's why the demons we face aren't just our thoughts. There is always a new

sheriff who keeps showing up in town, unexpected and uninvited. **Reality**.

An unknown reality is the anxious minds ultimate double whammy—the realization that you have completely no control over how you think and no control over what's going to happen next.

Life is an infinite collection of moments, both good and bad. Much like the mind, life itself is duality. It is the perpetual balance of unexpected, happy, sad, mind-blowing, "I can't believe I'm going through this," and "Did that really just happen?" moments. *We truly never know what's going to happen next.*

The unknown can be extremely exciting or absolutely terrifying depending on how you choose to look at it.

Up until this point in time, I found myself living and writing out the answers to the questions:

What happens after chaos because of chaos?

What happens as I start to face the wrath of reality and the war in my mind at the same time?

What is the aftermath of my unrest?

Everything that happened next:

Where are we in time?

It will always feel like we're running against time

Or, *running out of it*

There's never enough of it

Or, *there's too much of it.*

WHERE ARE WE IN TIME WHERE ARE WE IN TIME WHERE ARE
WE IN TIME WHERE ARE WE IN TIME WHERE ARE WE IN TIME
WHERE ARE WE IN TIME WHERE ARE WE IN TIME WHERE ARE
WE IN TIME WHERE ARE WE IN TIME WHERE ARE WE IN TIME
WHERE ARE WE IN TIME WHERE ARE WE IN TIME WHERE ARE
WE IN TIME WHERE ARE WE IN TIME WHERE ARE WE IN TIME
WHERE ARE WE IN TIME WHERE ARE WE IN TIME WHERE ARE
WE IN TIME WHERE ARE WE IN TIME WHERE ARE WE IN TIME
WHERE ARE WE IN TIME WHERE ARE WE IN TIME WHERE ARE
WE IN TIME WHERE ARE WE IN TIME WHERE ARE WE IN TIME
WHERE ARE WE IN TIME WHERE ARE WE IN TIME WHERE ARE
WE IN TIME WHERE ARE WE IN TIME WHERE ARE WE IN TIME
WHERE ARE WE IN TIME WHERE ARE WE IN TIME WHERE ARE
WE IN TIME WHERE ARE WE IN TIME WHERE ARE WE IN TIME
WHERE ARE WE IN TIME WHERE ARE WE IN TIME WHERE ARE
WE IN TIME WHERE ARE WE IN TIME WHERE ARE WE IN TIME
WHERE ARE WE IN TIME WHERE ARE WE IN TIME WHERE ARE
WE IN TIME WHERE ARE WE IN TIME WHERE ARE WE IN TIME
WHERE ARE WE IN TIME WHERE ARE WE IN TIME WHERE ARE
WE IN TIME WHERE ARE WE IN TIME WHERE ARE WE IN TIME
WHERE ARE WE IN TIME WHERE ARE WE IN TIME WHERE ARE
WE IN TIME WHERE ARE WE IN TIME WHERE ARE WE IN TIME
WHERE ARE WE IN TIME WHERE ARE WE IN TIME WHERE ARE
WE IN TIME WHERE ARE WE IN TIME WHERE ARE WE IN TIME
WHERE ARE WE IN TIME WHERE ARE WE IN TIME WHERE ARE
WE IN TIME WHERE ARE WE IN TIME WHERE ARE WE IN TIME
WHERE ARE WE IN TIME WHERE ARE WE IN TIME WHERE ARE
WE IN TIME WHERE ARE WE IN TIME WHERE ARE WE IN TIME
WHERE ARE WE IN TIME WHERE ARE WE IN TIME WHERE ARE
WE IN TIME WHERE ARE WE IN TIME WHERE ARE WE IN TIME
WHERE ARE WE IN TIME WHERE ARE WE IN TIME WHERE ARE
WE IN TIME WHERE ARE WE IN TIME WHERE ARE WE IN TIME
WHERE ARE WE IN TIME WHERE ARE WE IN TIME WHERE ARE
WE IN TIME WHERE ARE WE IN TIME WHERE ARE WE IN TIME

WHERE ARE WE IN TIME WHERE ARE WE IN TIME WHERE ARE
WE IN TIME WHERE ARE WE IN TIME WHERE ARE WE IN TIME
WHERE ARE WE IN TIME WHERE ARE WE IN TIME WHERE ARE
WE IN TIME WHERE ARE WE IN TIME WHERE ARE WE IN TIME
WHERE ARE WE IN TIME WHERE ARE WE IN TIME WHERE ARE
WE IN TIME WHERE ARE WE IN TIME WHERE ARE WE IN TIME
WHERE ARE WE IN TIME WHERE ARE WE IN TIME WHERE ARE
WE IN TIME WHERE ARE WE IN TIME WHERE ARE WE IN TIME
WHERE ARE WE IN TIME WHERE ARE WE IN TIME WHERE ARE
WE IN TIME WHERE ARE WE IN TIME WHERE ARE WE IN TIME
WHERE ARE WE IN TIME WHERE ARE WE IN TIME WHERE ARE
WE IN TIME WHERE ARE WE IN TIME WHERE ARE WE IN TIME
WHERE ARE WE IN TIME WHERE ARE WE IN TIME WHERE ARE
WE IN TIME WHERE ARE WE IN TIME WHERE ARE WE IN TIME
WHERE ARE WE IN TIME WHERE ARE WE IN TIME WHERE ARE
WE IN TIME WHERE ARE WE IN TIME WHERE ARE WE IN TIME
WHERE ARE WE IN TIME WHERE ARE WE IN TIME WHERE ARE
WE IN TIME WHERE ARE WE IN TIME WHERE ARE WE IN TIME
WHERE ARE WE IN TIME WHERE ARE WE IN TIME WHERE ARE
WE IN TIME WHERE ARE WE IN TIME WHERE ARE WE IN TIME
WHERE ARE WE IN TIME WHERE ARE WE IN TIME WHERE ARE
WE IN TIME WHERE ARE WE IN TIME WHERE ARE WE IN TIME
WHERE ARE WE IN TIME WHERE ARE WE IN TIME WHERE ARE
WE IN TIME WHERE ARE WE IN TIME WHERE ARE WE IN TIME
WHERE ARE WE IN TIME WHERE ARE WE IN TIME WHERE ARE
WE IN TIME WHERE ARE WE IN TIME WHERE ARE WE IN TIME
WHERE ARE WE IN TIME WHERE ARE WE IN TIME WHERE ARE
WE IN TIME WHERE ARE WE IN TIME WHERE ARE WE IN TIME
WHERE ARE WE IN TIME WHERE ARE WE IN TIME WHERE ARE
WE IN TIME WHERE ARE WE IN TIME WHERE ARE WE IN TIME
WHERE ARE WE IN TIME WHERE ARE WE IN TIME WHERE ARE
WE IN TIME WHERE ARE WE IN TIME WHERE ARE WE IN TIME
WHERE ARE WE IN TIME WHERE ARE WE IN TIME WHERE ARE
WE IN TIME WHERE ARE WE IN TIME WHERE ARE WE IN TIME
WHERE ARE WE IN TIME WHERE ARE WE IN TIME WHERE ARE
WE IN TIME WHERE ARE WE IN TIME WHERE ARE WE IN TIME

Ask Yourself,

Where are you in this exact moment?
How do you feel?
Take a look around you.
What do you see?
Are there people? Is the sun sitting peacefully in the sky above your head with the clouds dancing merrily around it? Or, is the sky clear and brilliantly blue? Is it cold? Is it warm? Is the sun beating down on your shoulders or is the wind rustling your hair? Are there birds? Are you inside? Outside?
Sitting or standing? Maybe you're laying down.
Are you on a train? In a chair? Surrounded by four walls?
Next to a window?

Wherever you are, whatever is happening around you, right now, this is your present moment.

You are present.

Establish where you are. Be present. Sit in the moment.
Think. Reflect. Embrace where you are *right now*.
Then, close the book.

Get up and move to different spot.

Go for a walk, call a friend, do *anything else*. How about eat a snack? Pretzels? Chips? An apple, perhaps? When you feel like it, when you're ready, come back and continue reading.

WELCOME BACK

Where are you now? How to feel? What do you see?

This is now your new present.

Now, think back to where you were and remember that moment.
Put yourself back in that spot again.

Remember that present.

Visualize where you were, what was around you, and how you felt.

Were there people? Was the sun sitting peacefully in the sky above your head with the clouds dancing merrily around it? Or, was the sky clear and brilliantly blue? Was it cold? Was it warm? Was the sun beating down on your shoulders or was the wind rustling your hair? Were there birds? Were you inside? Outside? Sitting or standing? Maybe you were laying down. Were you on a train? In a chair? Surrounded by four walls? Next to a window? Remember that moment.

Guess what?

You just time traveled.

Did I lose you? Let's break it down.

Physically, time travel is impossible. At least, *for now.* But until we get our hands on a fancy Back To The Future-esque time machine, let's stick with the easiest, most accessible (and totally free!) form of time travel available today—formally known as our memory. Are you with me?

Have you ever thought about the fact that every time you reminisce, you're theoretically time traveling with your mind?

That's right. *We can visit the past whenever we want simply by remembering it.* It always exists in our minds.

The importance of the past is that we get to learn from it. It shapes us. Creates us. Makes us who we are. Life's infinite collection of moments build off of one another to create the reality we're currently living.

Everything that has happened to you has somehow led the moment you're in *right now*. That's why flashing back to the past every now and then is important. It allows us to connect the dots of our bigger picture present. We can take the sequence of events and see how they stacked up to get us where we are. The ability to bounce between past and present is essential to shaping our future.

So, let's do it with some poetry, shall we?

Buckle up.

We're about go everywhere in time.

THE KEY

Pay attention to the top of the page as you read
We'll be jumping from past to present as we move through the story

If we're "forward in time" the arrow will point this way ⟶

⟵ If we're "back in time" the arrow point this way

Newton's Laws

NEWTON'S FIRST LAW OF MOTION:

An object at rest stays at rest and an object in motion stays in motion.

I know what you're thinking, "How does something that I learned in elementary science class have anything to do with anything at all?"

Well, let me tell you—science has something to do with *everything*.

In my opinion, when you take this statement out of its scientific context it's the perfect metaphor. First, strip out "objects" and forget about whatever your 5th grade science teacher said. Then, throw every possible notion of science from the sentence. After you've boiled it down to just words on paper, take the statement for exactly what it is and insert *yourself*. You get this:

You at rest stays at rest. You at motion stays in motion.

Did the light bulb go on? If you don't take action on an idea or a goal it's not going to happen. You have to take control of your dreams in order to make them a reality. This is a universal law, a simple fact of life, and *it's science.*

One of Hip Hop's greatest, Gangstarr, once said, "Only by actions do any ideas solidify." It's a simple lyric with a profound meaning. You have to take action to make things happen. If you stand in place, you will not move. To Newton's point:

If you are an object at rest, then you will remain at rest.

However, the moment you decide to take action, work hard for your goals, and move forward in the direction of your dreams *you become an object in motion.*

Remember, an object in motion, stays in motion. It's all up to you whether or not you want to stay in place or keep moving forward. It's important to know that no matter which you decide, you are in control of the decision to do so, but you are not in control of how reality plays out. Once you get moving on your dream, it will continue moving—unless you let reality stop you. Sometimes things don't work out and you have to **choose** to keep moving.

Ask yourself: Will do you whatever it takes to keep moving, even if reality tries to stop you? Even if mentality tries to stop you? Are you an object at rest? Or are you an object in motion?

I am an object in motion.

NEWTON'S SECOND LAW OF MOTION:

The force acting on an object is equal to the mass of the object times its acceleration.

In other words, this is the famous equation: $F = m \times a$ (f = force, m = mass, a = acceleration). Don't worry, we're not here to do math. Again, throw away any pre-existing scientific knowledge you may have and let's break this down metaphorically. In this case, I was the mass and the rate at which I was accelerating was inconceivable. Poetry was the force that was pushing me forward. Remember this: *Whatever it is that makes you decide to become an object in motion will continue to propel you forward, so long as you roll with it instead of against it.*

GO WITH THE FLOW

In mid-October 2019 I had just finished the final manuscript for *Out of Chaos*. It was freshly printed and safely housed in a manila envelope, labeled "final." It was glued to my side. I kept it with me at all times in my bag and made sure it never left my sight—even though I had no idea what to do with it, or what to do next. Two realities stood in my way: the first, I was still afraid to share my poetry. The second, I had to figure out how to get published. At the time, I didn't realize I would end up killing two birds with one stone.

Something inside of me still repelled against the thought of sharing my work. Even though the Artist had successfully helped me realize the importance of sharing my poetry, the harsh reality was that he was only one person in a world of many. I had to learn to open up to that world. This resulted in the random act of reading to strangers at the park. It wasn't enough. The inherent need to push myself further was a lingering force

that surrounded me. How could I make my words be heard? How could I conquer my fear? Instagram seemed like a sellout and I didn't like the idea of hiding behind a screen. I needed to find a way to put myself out in the real world.

Around this time, my agency was pitching a huge account. I decided to go to the office on a Saturday to help out on whatever was needed. Here's the thing—I *didn't* have to go to work that day. I could've spent my Saturday *any other way.* But I didn't. I chose to go to work. It was one simple decision that set everything else in motion.

It was around 2 pm when I finished my project. As I was getting ready to leave, I started chatting with my boss. He mentioned a website that offered free events around the city and since I had nothing to do for the rest of the day, I looked it up.

The first event that popped up was hosted by The Irish Poet's Society. I clicked the link and discovered that it was happening in less than 30 minutes. The venue was only a few blocks away, and of course, I wasted no time. Frantic, I grabbed my stuff, jumped from my seat, and dashed out of the office.

I rounded the corner of 51st and 12th and scanned the street. My GPS rattled off that I was 400 feet away, but there was no evidence of a poetry society in sight. No sign. No people. The building in front of me was run-down and desolate. The cracked white paint peeled off the concrete like the bark of a birch tree. I glanced at the map on my phone and saw that the glowing blue dot was exactly where I was standing. I put my fate in the hands of Siri, took a deep breath, and walked inside.

It's true what they say, *never judge a book by its cover.* To my surprise, the white room was elegantly set and full of people. The walls were lined with frames of poetry, and there was small bar in the back. A jolly bartender in a gold-lined vest was merrily passing out glasses of wine and coffee. The room was filled with the soft whispers and chuckles of eclectic, well-dressed writers as they chatted about literature. I slipped into the crowd and let myself melt into the unfamiliar and intriguing atmosphere.

I sipped on my glass of wine and observed the group of well-established

Irish poets; trying desperately to blend in but definitely standing out. Naturally, I sparked up conversation with a few mingling strangers, nodding and smiling as they babbled away about their publishers. Slightly woozy from the wine and fake schmoozing, I hardly noticed as we were ushered down a black hallway and into a dark auditorium. The stage contained a single podium and microphone in front of a scarlet curtain back-lit by a single golden stage light.

I claimed a seat in the last row and sunk into my surroundings. The lighting was dim and intimate. The soft glow of golden light radiated from the stage and hovered above the audience. The room was full of whispers and snickering and the smell of wine lingered in the air. Then, a hush rushed over the room and the crowd went silent. A women sauntered onto the stage, each footstep soft and steady. The clack of her heels reverberated off the walls and echoed throughout the room. She stopped at the podium, took a deep breath, and began to read a poem. The epiphany hit me like a ton of bricks.

"That's it" I thought. "That's exactly what I need to do next."

And, that's exactly what I did.

NEWTON'S THIRD LAW OF MOTION:

Every action has an equal or opposite reaction.

This is the best law of them all. It's the most fundamental rule of science and of life. Everything in the world consists of cause and effect. Every choice has a consequence, every moment has an outcome, and every step leads to the next.

Every single action has a reaction.

Remember, I'm an object in motion. I was rolling full speed ahead and ready to take action. After The Irish Poet's Society, I began the quest to find a way to get on a stage. Of course, this was a task that would have me facing some of my biggest fears: stage fright and sharing my poetry. Let's not forget, I was also still battling the thought of "not being good enough."

This was a blind swan dive into a pool of the unknown. I didn't know what I was doing, I was just doing it. Every time my negative side popped in to try and stop me, I uttered, "Not today!" and continued. Every time "reality" tried to get in my way, I walked around it.

It was November 7, 2019 and almost one year since I had written my chaos inducing poem *The Ambivalent Amphibians*. I spend the morning furiously googling poetry events in New York City. Fatefully so, I stumbled upon a random open mic happening that very same night. I immediately bought a ticket.

"This is it," I thought. "It's time to break the walls."

This particular open mic was hosted in the outskirts on the Upper West Side, not too far from Harlem. Luckily, I arrived early. I figured being the first one there would make it easier to avoid the whole "everybody knows each other thing." It was quite the eclectic setting. Deep yellow booths lined the interior of the bar and ethnic art hung from the walls. R&B music blasted in the background. The bar was buzzing with culture and positive vibes. I walked in and sat awkwardly in the back—feeling a little out of my element but not uncomfortable. I squirmed in place, squeamish and uneasy about throwing myself into the uncharted poetic waters.

As I observed the room, a man walked over to me. He reached out his hand and said warmly, "Hi, I'm Tonii!" Yet again, I was face to face with my favorite life lesson: The best people you meet are always unexpected and always for a reason. He began telling me about the open mic and his recently published book.

I cut him off mid-sentence, "How'd you do it?"

"Do what?" He asked.

"Publish your book..." The manuscript for *Out of Chaos* was practically about to jump out of my bag. Excitement over shadowed my anxiety, bubbled to the surface of my chest, and rose to my vocal chords.

"What do you mean?" He laughed, "I'm starting a publishing company!"

I smiled, unable to fight the words that were begging to jump out of my

mouth. For the first time since finishing my manuscript, I blurted out, *"I wrote a book."* **Just like that, the seed was planted.**

I peered around the room nervously as the event began. My heart pounded in my chest. My anxiety ran wild. Every conflicting thought came rolling in, ready to attack. "Nobody is going to like your poetry" "Bad writer!" "You're going to embarrass yourself!" "What are you doing"

"Why are you even here?"

Oh hello, self-number two! The queen of self-sabotage. The endless loop of negative thoughts were like being on a broken Ferris Wheel. It was spinning fast and out of control and I was stuck inside. How fun!

I fiddled with the strap on my bag as I glanced around the room. There was another poet sitting directly across from me scribbling furiously in a notebook and reciting to himself. Unable to resist making a new friend, I said hello. His name is Donavan McNeil (aka Macadon Blackheart). At the time, I didn't know he was the feature of the evening. In fact, I didn't even know what a feature poet was. We struck up a conversation and I babbled on about how nervous I was. His words of encouragement distracted me from what was going in the background. He explained his writing style and what it was like being a spoken word artist. Then, he performed. I was immediately inspired. Not only that, but it was the first time I had ever seen real, raw, spoken word. The poem he performed was called "Irving Word." It was about feeling not good enough but continuing to push forward despite facing rejection in the poetry community. After listening to his piece, something inside of me clicked. It gave me the spark of courage I needed to proceed. Suddenly, there was a roaring fire of fearlessness blazing within me.

"I can do this." I thought to myself as they called my name.

My heart caught in my throat, my stomach dropped to the floor, and I shakily rose from my seat. Step by step, I made my way over to the microphone. The room felt like it was closing in, the lights were blinding, and the faces behind the bar twisted and morphed into unrecognizable blurs.

I knew exactly what piece I was going to do: *The Ambivalent Amphibians*. It was the perfect full circle moment—to be able to stand up and proudly perform the piece that had sent me spiraling into chaos. I was about to shatter every wall. I was about to share my most personal poem, out loud, to a room full of people. All eyes and ears on me. *How absolutely terrifying.*

However, I knew that if I could conquer this, I could do anything. It would be the greatest triumph and the ultimate testament to facing myself. Remember this: *you have to have to stare your fears in the face and slash through them.*

I closed my eyes, took a deep breath, and let the walls of fear crumble down. To my utter surprise, I delivered the poem flawlessly.

The action of deciding to attend this event had two equal reactions: performing poetry and publishing *Out of Chaos*. In the months following this night, I began performing all over the city while Tonii and I got to work on publishing my book.

Two birds, one stone, a little bit of fate, and here we are!

Alright Reader, now that we're all caught up, let's go somewhere in time between *Out of Chaos* and now.

The Aftermath of Unrest

We're on my roof in the early days of NYC quarantine.

Smoldering Skies

The sky is dark.
The city is silent.
There are no cars on the street, no hum from passing taxis, and no faint conversations from people walking by. There is no moon in the sky. Only a few lights from the surrounding buildings faintly light the scene. For the first time since moving to New York City, it is dark enough to see the stars.

Everything in the world is uncertain, the recipe of disaster for an anxious mind—for any mind really. It's just me, the stars, and my roof.

I sit down to write *"Which Side"*

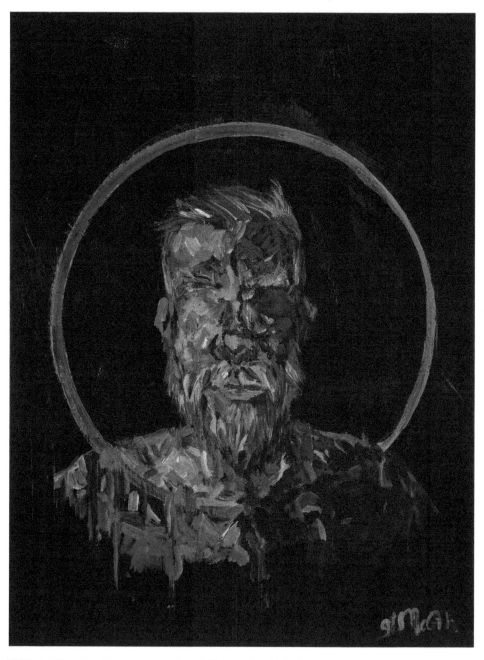

"Self Portrait Three,"Acrylic on canvas, 12 x 16 in., 2018. Artist: Grant McGrath.

Which Side?

I pondered my lingering madness
All of my restless endeavors
Considered myself as the valiant bird
Stripped of its wings and its feathers

I thought about love and I thought about hate
The act to create and destroy
Both the anger and sadness that sits on my soul
The balance of sorrow and joy

I thought about jealousy—green as jade
And I sat with my sickening pride
I stood face to face with ego and flaw
My evil and benevolent side

I thought about kindness and loneliness
I screamed at the stars from my roof
Encaged in a world of steel and brick
Searching the cosmos for truth

I stared at the heavens, I cried to the skies
Begged for a definite path
I prayed for a clear direction and *got handed a road split in half*

I sat and I wondered how sitting in place
Seemed, in part, why I couldn't decide
I discovered what covered my judgment
The truth—I had buried in lies

I have deduced that there is no use
This inevitable balance of two
I'll always be split into sides of myself

Confused by which one to choose.

We're on Park Avenue in the middle of the pandemic.

Silence and Eyes

There's not a single soul in sight
On these silent city streets
My soundless footsteps seek the people
Locked inside for weeks
Never thought I'd see the day

That New York City sleeps...

Asphalt Skies

Abandoned roads lay barren
Beneath the asphalt sky
New York City, once awake
Now rests
Unoccupied

New York City!
Full of life!
The greatest!
Built from dreams!

Hustle and bustle!
Taxis and people!

Now—*deserted streets*

The buildings standing vacant
New York, without a voice
Not a tune from Broadway
Sheer silence fills the void

The rushing blur of faces
Once mirrored in the glass
Here lies empty concrete
As nothing shuffles past

Fear and desperation
Has made the city freeze
The big and boisterous Apple
Now, poisoned by disease

Please wake up New York!
We need your heart to beat!
The greatest city in the world
Is not supposed to sleep

But, sadly new reality demands for our retreat
And left behind is nothing besides

Asphalt skies and empty streets.

"Quarantine" meant being alone with myself on an entirely new level. I didn't have people around to break me out of my racing mind. It was just me, empty New York City, and my thoughts. That's how it was for most of us. Even walking alone became a different kind of wandering. There were no people. There was no "New York Energy." It was the shell of a city—as if the buildings were dry bones, resting peacefully in a graveyard of concrete.

The soul of the city is the endless stream of diverse people that flood the streets. It's the liveliness of bars and restaurants. The honking of taxi cars and the rumble from the subway beneath your feet. It's the smell of Halal carts, sidewalk garbage, and cherry blossoms.

New York City is electrifying, unexpected, and spontaneously chaotic in the most wonderful way. It's a blur of people, places, and things all happening at once. New York City is alive. It's the city that never sleeps.

Until it does.

Even though we were supposed to stay inside as much as possible, that didn't stop me from restlessly wandering the empty city. When the Governor said it was okay to go for walks, that's all I needed to know. I followed all the rules…mask on, sanitizer handy, and distance kept between me and any lingering stranger on the street (although there were very few).

It was like being the last person on Earth. I walked in circles up and down 1st Ave, down 54th to Park, and back down 53rd—every single day, multiple times a day. It was safer staying close to home and it was better to walk with my thoughts instead of sit in place with them. At least I could blast music and lose myself in the surrounding emptiness of the City. These lonely walks became ritualistic. It was my new routine and a way to keep my sanity in check throughout the day.

The beginning of April was the worst of the pandemic. It was just before we "hit the climax" and were steadily approaching the darkest of days. On April 5 during one of my walks, I decided to sit on Park Avenue.

It was just after a massive downpour and the concrete was shiny and sleek. The air smelled of rain and gravel. The city was absolutely silent. The rain had come and gone but there was nobody to get caught in it. The atmosphere was eerie, dark grey, and lifeless. The sound of the rushing fountain reverberated off the buildings and echoed down the empty street. The deep smoldering sky blended with the concrete. It was as if there was no difference between clouds, building shadows, and asphalt. Everything was one—blanketed in the ashy stillness of silence.

It was truly mind-shattering. Park Avenue was once one of the busiest streets in New York City and now it was *completely empty.* There wasn't car in sight nor a person. Every few minutes, I would glance up from my notebook and see someone hopping over puddle and scurrying away; or a couple would walk by with their hoods pulled tight around their heads and masks covering most of their faces.

The city, in this moment, was now a world of two things: *silence and eyes.*

This was an extremely unsettling thought. Pure loneliness. At the core of my being, I knew this was going to get worse before it would get better. The only way out of anything, is through it. Although uncertainty, sadness, and silence hung heavy in the air, I couldn't let it weigh me down. It occurred to me that I would have to do everything in my power to accept and adapt to this new reality. In order to do that, *I would have to find balance.*

We're on East 53rd and Lexington.

Christmas in New York

Christmas is in one week and the city is bursting with holiday cheer. Nothing quite compares to New York City during the holidays. The trees that line the streets are adorned in lights. They twinkle overhead as herds of people merrily stroll past; their arms full of shopping bags and eyes full of wonder as they marvel at the extravagant window displays.

The air bites my cheeks. The smell of coffee and cinnamon is wafting from a nearby bakery. It's a frigid night, but with my hands stuffed in my pockets and hat pulled tight over my ears, the winter chill is tolerable. I'm pacing up and down East 53rd, breathing in the smells from the bakery, over thinking *Out of Chaos,* and trying to figure out what to do next.

I'm in the middle of a battle with doubt.

Slowly Unknowing

I've walked this twisted road before
Many times, in fact
I've braved the fire countless times
And learned how to adapt

I'm seeking validation
A revelation of the truth
But, I am so *unsure*
Of what's to come and what to do

I simply just don't know
Words that linger on my lips
A snake of doubt that's wrapped me up
And slowly it constricts

It's fangs are dripping inhibition
Venom laced with shame
It slowly sinks it teeth in me
And poison floods my veins

It slithers around my neck
Hissing lies and evil whispers
I'm torn between it's foreign tongue
And what I should be thinking

I free my hands to clutch the snake
Foul scales in my grasp
Reclaiming what it's tried to steal
And slowly it unwraps

It flails and it fights
But, I am so much stronger
It dangles over waiting flames
It's fate—now mine to slaughter

I'd like to say that it's what's best
But truly
I don't know
So I hold it over the fire
Wondering...

Why I can't let it go.

Let's start with a quick Google search of my good friend: *doubt.*

Google defines doubt as, "A feeling of uncertainty or lack of conviction."

Let's look deeper.

Wikipedia says, "Doubt is a mental state in which the mind remains suspended between two or more contradictory propositions unable to assent to any of them." Yes. Let's keep scrolling. "Doubt on an emotional level is indecision between belief and disbelief. It may involve uncertainty and distrust on certain facts, actions, motives, or decisions. Doubt can result in delaying or rejecting relevant action out of concern for mistakes or missed opportunities."

Oof.

Doubt boils down to this: it's the thing that sits right smack dab in the middle of all decisions. It is the bridge between "yes" or "no," positive or negative outcomes, this way or that way, perception or reality, and change or complacency. To have doubt is to question your options in a negative context. *Doubt is never a positive.* It always plays the role of devil's advocate in every decision and somehow always finds a way to hold you back. We always hear it like this, "I was so happy! And then, doubt set in." Yep, as soon as doubt rears its ugly head, it's as if going with your gut becomes near impossible.

Doubt survives on its own, but it also has a very best friend: indecision. Usually, the two are always hanging out and feeding off of one another. Without doubt, every choice would be almost immediate. You wouldn't question the outcome or have to weigh the options for which one is the better of the two. Let's not get this confused with making logical decisions though, it is always a smart move to look at situations from every angle. Doubting yourself or someone else, that's when things get messy. Doubt is not to be confused with "This is the wrong decision for me." *Doubt is the emotion that sways you from the right decision because of fear.*

When you remove doubt from the picture, every possible choice you're presented with becomes a free-for-all, meaning, you only have to choose between what you truly want and what you don't. Life plays out as it should and a negative reality can have no power to hold you back. You have eliminated doubt and have allowed yourself to follow your truest instinct.

When doubt moves into the mind, it settles in, and becomes really hard to evict. Doubt is the worst possible tenant. It never cleans up after itself and is always inviting its rowdy friends over: indecision, hesitation, and confusion. They love to throw parties. When logic, confidence, and certainty show up at the door, the party is too crowded, too rowdy, and there isn't enough of them to break it up. They leave and return only when doubt finally finishes its bender.

Remember: The only person who has the power to kick out doubt is *you*.

So, what are you going to do about it? Are you going to let doubt walk all over you? Are you going to let it throw a party, trash the place, and leave you there to clean up the mess? Are you going to let doubt knock you off your tracks?

Or, are you going to take control? Are you ready to let certainty run the show?

It's time to finally kick pesky doubt out of the house once and for all.

And when you do, *lock the door.*

We're on the roof of my apartment building.

Eerie Evenings

The air is thick and a cool mist swirls around me.
A band of heavy grey clouds is blanketing the sky, their bellies
full of rain. I'm propped against the brick looking out at the city
in despair. The atmosphere is reminiscent of the day I wrote
The Duality of Selves. The wind howls through the buildings
and the air stings my cheeks as it begins to lightly drizzle.

"What is the missing the piece?" The thought racks my brain.

I chew on my cheek and fiddle with the wet pen in my hand.

Raindrops hit my face and the city lights blur as the rain falls
faster and in fat droplets.

"Miserable weather," I sigh.

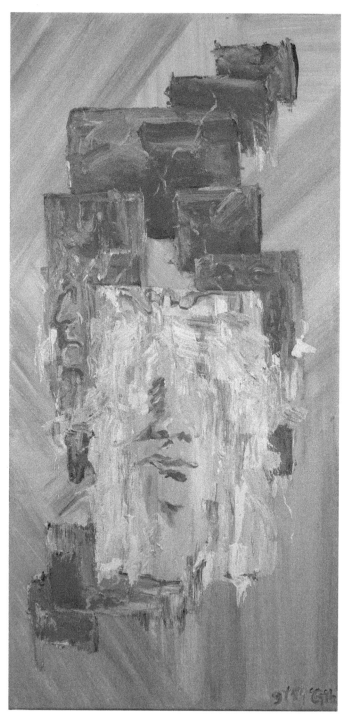

"The Curious Case of Rectangle Face," Acrylic on canvas, 18 x 36 in., 2018. Artist: Grant McGrath.

The Missing Piece

You, me, and our unsettled selves
Locked in a room, *subdued*
Facing an undone impossible puzzle
We wonder if we should resume

This puzzle of undefined purpose
An oddity, that seems out of place
The image, unfinished, enigmatic
We sit, unresolved, face to face

This unfixed photo, before you and I
A project, we've deemed incomplete
We ponder a picture that doesn't make sense
Because it's still missing one piece

Disputing our separate depictions
Finding meaning proves rather elusive
Two selves, unaligned, incessantly bicker
And an outcome remains inconclusive

This innominate image demands explanation
But our selves cannot see it the same
We argue interpretations
Pointing fingers at who is to blame

Enough is enough of this madness
Our quarreling selves call it quits
This puzzle, forever a mystery
And eternally unfinished, it sits.

Now, You, and I and our conflicting sides
As one, accept defeat
It ripped us apart and brought us together

The puzzle with one missing piece.

The Duality Of Selves, poem #11 from *Out of Chaos*, was meant to be a conundrum. It was purposefully left open-ended and up for interpretation. For some, it became as literal as two people in a room. For others, it was as abstract as the concept of having a variation of "selves." The intent was to convey the battle of opposite mentalities using the metaphor of a puzzle.

The original poem reflects two sides of the self trying to figure out a situation and disagreeing on the outcome, with the cliff hanger being the missing piece. If the first question you asked yourself after reading it was "What's the missing piece?" Then, you're out of luck. Guess what? *I asked myself the same thing and I had no idea.*

First, I considered the possibility of it being love. Then I thought, maybe it's hope or strength or simply understanding. Or, the missing piece could even be myself. I couldn't seem to figure it out, even though I was the one who wrote the poem. I sat with the ending line 'Two selves and one missing piece' for many months. Was the missing piece another person? Was it confidence? Sanity? Acceptance? Faith? Trust? All of them fit. The beauty of it is that the missing piece can be *whatever you want it to be.* But...I wanted the answer.

There were so many days spent on my roof contemplating everything. On this particular day, the missing piece was all I could think about. The rain fell silently and the sadness of New York City swirled in the air around me. I sat there, staring out at the foggy skyline as the droplets stung my cheeks and sighed to myself, "At least the sun will come out soon and all of this grey sky will be blue."

It was an interesting notion that while pondering the mysterious missing piece and *The Duality of Selves*, I was experiencing the duality of nature. The duality in reality. Nature is the perfect balance of good and bad, rain and sun, hot and cold, and day and night. The world itself is the perfect balance of light and dark.

We will always have two sides of ourselves. There will always be the duality of a positive and negative mentality just like there will always be the duality of rain and sun. More often than not, we allow them to conflict

and these opposite mentalities end up working against each other. This creates chaos. In order to find peace, you have to make them work together. *Good and bad must exist in harmony.*

The acceptance of this truth and learning that both sides can work as one balanced unit creates peace of the mind. Think of it like a seesaw with positivity on one side and negativity on the other. Too much of one, and the seesaw stays on one side. It's remarkably easy to let negativity overrun a positive mentality. Balance can seem near impossible if you let one outweigh the other. That's why achieving balance and arriving at peace of mind is much easier said than done.

Unfortunately, there is always back and forth between the two sides.

We're on 52nd, passing Park Avenue, walking towards Lexington.

Rush Hour

Hundreds of people swarm the sidewalk.
Everyone is going somewhere.
Everyone is on the move.
I imagine getting lost in the crowd.
A beautiful disappearance into the stampede of suits and shiny shoes.

Out of Chaos officially releases in a few days.
Every thought is racing through my brain.
Half of me is excited.
The other half is terrified.
I am split in two and caught in the middle of both sides.

I am like a river that is chaotically flowing between...

Two Lands

I am the river that splits two lands
The always "in between"
Cutting through the soil
That divides *two sides of me*

On one side
An oasis
A wealth of Nature's best
Where flowers dance against the breeze
And only ease exists

An effortless splash
On golden sands
A happy crash to shore
The creatures greet me merrily
The water, clear and pure

Across this running river
Barren, cracked, and dry
The land that houses darkness
My harshest, hostile side

A murky swamp at rivers edge
Mud, as thick as clay
It swallows whole my rushing joy
And feeds my disarray

This other land, inhabitable
Yet sometimes feels like home
As I stay ever-flowing
Against the harrowing unknown

Then I split in two
And I cut the land in three
Unclear of which direction

Choosing sides, impartially
This third land in middle
A balance—bad and good
The place that seems to make most sense
Yet always, overlooked

So, I move between these coastlines
A sporadic, illogical flow
Crashing over jagged rocks

Unsure which way to go.

The city of Babylon rests in Mesopotamia, a land right smack dab in the middle of two rivers—The Tigris and the Euphrates. Back in the day, these rivers were the heart of Mesopotamia. They provided the land with an abundance of natural resources that allowed the cities within them to thrive. It is known as "The Land Between Two Rivers." This simple fact reminded me a lot of Manhattan and how it's nestled between the Hudson and East River.

Every morning, I stare out at Brooklyn on the other side of the East River. *I am always staring from the land between two rivers yet I am overlooking a river that splits two lands.*

How beautifully poetic. So, it flows:

Land always remains but a river is ever flowing. Just like time, it only moves in one direction—forward. As you move down the river, you pass what is around you. You take in your surroundings as you go. We change as we move forward on the ever-flowing river of time, but we can find ourselves rowing against it when we hold onto the past. It takes mighty strength to paddle an oar against a flowing river and in our attempt to row backward, we can find ourselves rowing in place.

When you go against the natural flow you end up not moving at all. The lesson in this? *Go with the flow.*

You have to learn from the lessons of the past as you float forward down the river of time. Do not try to go back. If you do, it is inevitable that you'll end up rowing continuously in the same spot. It is never a good thing to get stuck in the past. You must learn from it, pass it by, and continue with the flow.

Take only the wisdom you've gained as cargo. Let the rest go.

This metaphor extends beyond letting go of the past. The river brings me back to Newton's first law of motion—*an object in motion stays in motion and an object at rest stays at rest.* A log floating down a river is an object in motion. Nothing can stop it from going anywhere but in the direction of

which the water is flowing. Well, nothing except *an outside force.*

This can be a person reaching in to pull it out, or a cluster of rocks that catches it. If the log is **you**, don't let anyone or anything pull you from the water.

Do not let reality catch you. Keep floating in the direction of your dreams, regardless of anything that tries to get in your way or stop you.

Last but not certainly not least, *the river as the mind*; ever-flowing between two lands—positive and negative. Sometimes it will splash onto the positive shoreline. Sometimes it will settle on negative sands. No matter what, the river of the mind has the power to flow freely between the two.

Dear Reader, remember, you have the choice:

You never have to stay on one side for too long.

We're in my apartment. Standing in the kitchen.

Rising Steam

Everything in my kitchen is small. It's a 4x12 square at the end of the apartment across from the front door. It's definitely a one-person-at-a-time kind of kitchen. There is a tiny gas oven and sink that sits under a row of cabinets. Yellow tile lines the wall and the countertop is cast with plastic granite. The fridge is squeezed tightly in the corner and the fluorescent light on the ceiling is broken. We rely on the dim glow from the hazy stove light, caked with grease from years of cooking. There is no microwave and anything that requires heating has to happen with the stove.

I light the first burner, grab a pot, and pour in some water from the sink. After a long heavy sigh, I reach up to grab a mug from the cabinet.

Yeah, it feels like a good time to make some tea.

Two Cups of Tea

Flame to kettle
Burning hot
Bubble
Boil
Brew
Whistling steam
Rising high
Fills the silent room

Fire to iron
Bottom charred
I leave the tea to stew
On the table, neatly set
Two cups
For me and you

Empty

The pouch of tea is bursting
Untold, forsaken herbs
In the water and slowly steeping
My lost, unspoken words

Dispersed

Dissolved

And unresolved

They manifest as they brew
Too hot to drink
Too strong to pour
These words long overdue

The tawny water fills your cup
Your nose—unknown aroma
Flooding from the kettles spout
The truth
Let's shed persona

It hits your lips
As you take a sip
And ask, but *why so bitter?*

"It's been steeping for too long," I say.

"My words, left unconsidered."

Nobody likes the elephant in the room.

This is one of the great lessons I have been continually learning:

Say how you feel and speak your truth.

Have you ever left something unsaid? Half said? Danced around the truth because of the fear of rejection or ridicule? Found yourself wishing you'd just said how you felt? Spoken your mind? Got that "thing" off your chest?

Ah, yes the dreaded elephant in the room is never a welcomed guest. Somehow, we always seem to invite it in. This elephant lingers when we don't speak our truth, feeding off of our unspoken words, growing stronger and fatter with each passing day.

Dear Reader, it's time to learn how to cut off the food supply.

It's seemingly easy to justify not saying how you feel in the moment with these five simple words: "I'll say it next time." Well, yes—next time *always* sounds like the right time. The sad reality is that we can never be sure we're going to get a "next time." Even if it's in the cards, we have no control over when it might be.

Many of us, including myself, are afraid to say how we feel in fear of losing the moment or ruining things. We toss around thoughts like "It's not the right time" or "When it feels right, I'll say it." Well, when you wait for the right time or the next time, you can end up missing a chance. When that opportunity passes, we can find ourselves sitting on the sidelines wondering, "What if." What if you'd just said it if you had the chance? What if you had told that person how you felt? What if you had spoken up? *What if?*

Remember, there is a difference between knowing when to take action and speak up and when to hold your tounge. But if it is truly something that needs to be said there may not be a right time or even a next time. If that's the case, here's the hard truth: *the time is always right now.*

All you have it this moment.

Dear Reader, you have to stop feeding the elephant. If you have something to say, if you have something on your mind, say it. Despite the fear of rejection or failure.

Why? *You have nothing to lose but "What if."*

I have found that regret stings far greater than rejection or ridicule. You never want to find yourself stuck in the endless loop of wondering what would've happened or how things could have been had you spoken up when you had the chance. More often than not, the things we leave unsaid can haunt us for a lifetime.

Find the courage to say how you feel.

Don't ever hold back.

Even if it doesn't go as planned, you'll never have to wonder "what if."

Go ahead Reader, take the tea off the stove, pour it, and kick that damn elephant out of the room.

We're on the roof again.

The Eye of the Storm

It's one of those days where rain just doesn't want go away and I'm propped against the edge of the roof door. The sky is grey and swelling with clouds. It had been raining on and off all morning. Occasionally, it would downpour and a rumble of thunder would shake the sky. The air smells of warm rain and asphalt. I look around my roof. It's more of an obstacle course, really. There are skylights, dips in the floor, drains, and frayed wires. The silver, reflective paint chips beneath your feet as you navigate over piles of lose nails and cigarette butts. I live smack dab in the middle of East Midtown Manhattan and depending on where you're standing, you get a different view of inside New York City. In the far-left corner, the Chrysler building peaks its head out from the sea of buildings. To the right is the Bloomberg Tower. Directly in the center is a tall and skinny rectangle building that resembles a tower. Lastly, there's everything else that fills in all the gaps between the buildings: apartments, offices, fire escapes, roof gardens, telephone wires, and streetlights.

I stare out at the tower and imagine it being the only building in the entire city.

I picture myself at the top of the tower...

Still Standing

Stuck in a teetering tower
Caught in the eye of a storm
The foundation
Unsteady, still standing
Unstable, the structure forlorn

The pain of the truth hits like lightning
Rejection, in thundering rumbles
It hits the base and quivers
And then, to the ground

It crumbles

The walls fall down
Surrounding the grounds
With pieces of brick and debris
So, I'm told
It would still be standing
If when looking out, I had seen

Before the storm
The tower stood tall
I peered from its sumptuous spire
The scene seemed perfect
But I was blinded

Seeing only my own hearts desire

Staring from the steeple edge
As grey slowly swallowed the sky
I ignored
The creeping storm
Deceived by a reckless mind

From this tower shrouded in clouds
The anger of nature brewed
My subjective opinion
Not a truth I'd been given
Slowly obstructed my view

The objection of unwanted outcomes
When perception becomes my belief
If I had just listened
Instead of insisting
Then I wouldn't be facing such grief

In front of the rubble, I wondered
Searched for the answers within
"How did this happen?" I asked
And then, intuition stepped in

"If you had seen past what you wanted to see
Had you not left fact abandoned
Had you accepted the truth of *what is*

The tower, *would still be standing.*"

A tower has multiple symbolic meanings. In most cultures, a tower usually stands for hope, freedom, faith and promise. To me, being at the top a tower meant *triumph.*

I imagined myself staring out at the world in triumph but sadly triumph made an immediate shift to truth. As soon as my pen hit the paper, the metaphor took an unexpected turn. Instead of a poem about victory, *Still Standing* became a testament to my unwavering ability to believe only what I want and not what reality demands.

Here is the lesson, dear Reader:

However triumphant the top may look from far away, not everything is exactly as it seems.

It is human nature to believe only what we want to believe. That's just simply how the mind is wired. Most of the time, we cannot see things for what they truly are. We are blinded by personal bias, opinions, and desire. It's easier to believe what we want than it is to believe the truth— especially when the truth isn't what we want to hear.

There's not much more to say about *Still Standing.* This one wrote itself and it speaks for itself.

If anything, remember to always keep your eyes and ears open. Look at situations from every angle. Remove your rose colored glasses and try to see things for what they are. It is never a good feeling to get lost in a false hopes. Things are not always as they seem. You must try to be diplomatic. You must try to accept all variations of the truth, even if it's not what you want to hear. I know this sounds harsh, but sometimes, tough love is exactly what we need.

What I'm trying to say is that if you're at the top of the tower...

Make sure you have a good set of binoculars.

We're on 8th Avenue between 53rd and 54th.

Broadway Lights

It's rush hour. The streets are packed with people waiting in line for Broadway shows, rushing to catch trains, and lingering in front of diners and coffee shops. It's freezing and plumes of breath dance around the crowds of people huddling in place. Their gloved hands are clutching steaming cups of coffee, in an effort to protect their fingertips from being nipped at by the Winter chill.

I lean up against the wall of a building and observe the surrounding scene in silence, savoring each slow pull from my cigarette. It was a long day. I'm tired. Frustrated. Cold.

The lights from a Broadway sign glow above me, casting my shadow on the concrete. My twisted silhouette lurks on the dirty gravel beneath my feet and catches my eye.

Hello, shadow side.

The Reflection of Happy

I caught you in a window
In the corner of my eye
I caught you in a puddle
In the reflection of the sky

I saw you in the pine trees
In the grass that meets the dew
In the pollen of the bees
In an ocean painted blue

Against the luminescent sky
Within a sparkling trail
I saw you in a shooting star
A fleeting comet's tail

Inside the lines of sunshine
In rising morning haze
Against the tie-dye backdrop
I caught you in the blaze

I see you in birds that glide
And dance around the clouds
In every blooming flower

Blanketing the grounds
I see you, happy side me
And yet, I turn away
Because I cannot be you

When my shadow takes the reigns....

Shadow Side

I villainized the mirror
Saw the flaws in my reflection
Demonized my own two eyes
Seeing only false perception

An empty stare, blank iris
Sorrow splashed across my face
A portrait in the looking glass
That cannot be erased

How silly of a mindset
To say I once believed
That the enemy I fought against
Stood just the same as me

Relentlessly, I loathed her
Our finger, pointing blame
But she is now my ally

And as one, we play this game.......... how foolish to betray her
When she shares the same ideals
Alas, the true assailant
Was the shadow at my heels

The reflection of my demons
Not the girl I crucified
But an umbra that now falls in step
And never leaves my side

I used to say my two selves
But this battle is of three
Casted on the concrete
Loomed my darkest side unseen

Hello, it's nice to meet you,
Shadow side of me.

Everything and everyone has a shadow side.

You, me, the moon, the earth and *even the sun* have shadows. When the moon moves in front of the sun on the ecliptic plane and casts its shadow over the earth, we see a solar eclipse. When the Earth moves in front of the sun, it casts its shadow into the cosmos. When the moon passes between the two, we witness a lunar eclipse. The science of shadows in the ethos is fascinating stuff. But, there are also the shadows in our reality on Earth— always there, *everywhere and anywhere.*

When we stand in front of the sun, our own shadow is cast on the sidewalk, on the wall, or wherever it seems to fall. Our shadow stays forever at our side (unless you're Peter Pan, of course). It is the constant reminder of yin and yang. When it comes to the concept of shadows, there is one important fact:

Wherever there is light, there is the reflection of dark.

Our shadow is inescapable. You cannot have light without dark and vice versa. We are the walking metaphors of duality itself.

We're back to the main thought: the mind is split in two between the negative side of the self and the positive side of the self. However, these opposites of the mentality are extremely malleable. They can be manipulated by simply shifting your perspective and your thought process. If you're seeing a situation in a negative light, or if your thoughts about yourself are negative, you have the power to change them, simply by shifting your thought process in a positive direction. I call it the "shadow flip." The second you recognize dark, capture it, acknowledge it, and flip it into light.

A shadow side is the permanent collection of your darkest attributes. Your shadow side is your ego. It's the aspects of who you are that reflect darkness. Nobody is perfect. We all have character flaws. We all have personality traits that make us who we are, both good or bad.

Let me break this down:

I am determined. **I am indecisive.**

I am kind. **I am jealous.**

I am honest. **I am reticent.**

Determined, kind, and honest are my light side.

Jealous, indecisive, and reticent are my shadow.

The goal is to recognize your shadow side and work on yourself so that only light has power. Think of it like this, you're walking down the street and the sun casts your shadow on the sidewalk. Depending on where the sun is in the sky, your shadow will either be in front of you, beside you, or behind you.

When your shadow is in front of you, your negative attributes take the lead. They create a negative mentality, which in turn, manifests a negative reality.

But, if your shadow is behind, you walk through the world with your brightest side leading the way. You are always aware that your shadow is there, but you are always two steps ahead of it.

You are always in control.

Shadow Side is the discovery of the shadow self. *The Reflection of Happy* is when the shadow side decides to steal your joy. Dear Reader, you cannot be happy if you allow yourself to fall victim to the shadows.

Stay in the light.

Keep the shadow at your heels.

We're in the same spot as always, that is, on the roof.

Change Is The Result of Existence

We cannot live without experiencing change. This brings me back to one of Newton's laws—every action has a reaction. Things happen as a result of one another. Things change. There is no escaping the reality of an ever-changing universe. Even on the simplest scale, you don't stay the same your whole life. You grow, from baby to toddler to teenager to adult.

Change is happening all around us, at all times.

The Ever-changing Equation

It's quite the complex equation
Finding the sum of existence
Life adds, divides, and multiples
Seemingly making...no sense and yet...

We're asked to *solve for x*
A daunting, strenuous task
In this case, x is purpose
And the answer?
Part of the quest

It starts with the addition of living
Plotting a map of experience
Molding our souls through moments
Feeding an undying curiousness

This multiplication of incidents
Accumulates friends and foe
You begin the addition of humans
As people come and go

Now, we divide both distance and time
Searching for where to go next
Quickly decide whose along for the ride
And those who are not...

We subtract

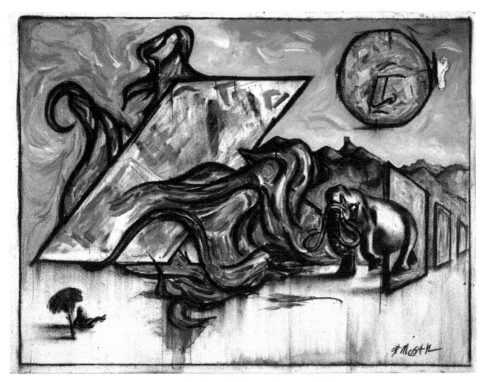

"Watching Time," Acrylic, charcoal on canvas, 18 x 24 in., 2018. Artist: Grant McGrath.

There's complications in the calculations
When we begin to work in reality
This conflicts with estimates
Presumed by a hopeful mentality

This messy equation is constantly changing
As multiple quantities mix
The variety of discrepancy
Repeatedly insists on a fix

Scratching our heads in confusion
We meticulously rearrange
And discover that life
Proves hard to solve

When there's a constant variable of change.

Einstein's cosmological constant was dubbed the greatest blunder in his scientific career following the discovery of Hubble's expanding universe theory. I'll spare you all the scientific details, but Einstein's theory essentially stated that the universe did not expand or contract. That's when Hubble stepped in to challenge Einstein's hypothesis. His theory stated that the universe is ever-changing and rapidly expanding. It was a direct opposition of what Einstein had postulated.

Unfortunately, Hubble's theory proved correct and Einstein had to abandon his hypothesis. He actually took it quite well and even applauded Hubble for having made, "The greatest discovery in the history of astronomy."

Talk about being a good sport.

I found the concept of a constant variable extremely interesting. I pondered the thought for many hours while being stuck on my rooftop. Hubble had cracked the code using his own constant (appropriately named the Hubble constant) *only his was based on the idea of something that was ever-changing.*

Huh, a constant variable to solve an ever-changing equation. How scientifically poetic...

I found it fascinating that scientists in the early 19th century were curious enough to even attempt solving the equation of an infinitely expanding universe. Learning about the history of the cosmos was a wonderful distraction from the chaos of Coronavirus, and I delved as deep as possible into the history of science. While pondering the remarkable discoveries of Hubble and Einstein, an idea crossed my mind:

What happens when the "constant" variable that isn't supposed to change, is "change" itself?

Where and when is that applicable? This was a total head-scratcher and a wildly abstract thought...my specialty. The more I sat with it, the more it made sense. If life was an equation it would require multiple variables: friends, family, moments, places, ideas, time, etc.

They're all variables that change or stay relatively the same, depending on how you choose to live.

We can't escape change, it **is** the constant variable of life—an integral part of life's equation.

I had just finished writing *Still Standing* and I needed to write something that didn't cause me to crumble. So, I sat with the thought of Einstein and his greatest mistake. I sat with my own great mistakes. I got lost in the stars and dwindling building lights. Then, in an effort to finally write something that had nothing to do with my own mind state, I configured *The Ever-changing Equation*. The perfect blend of science, math, life and poetry. It was also the moment I realized, science and poetry would somehow be dancing together for the rest of my writing process—at least during the completion of this book.

We're on Park Avenue in front of the Met Life building.

The Point of Infinity

It's not exactly prime time to be outside. The streets are empty and it's late. It's me, the soft glowing buzz of the streetlights, and the faint noise from the fountains a few blocks away. The **architecture** on Park Avenue is stunning. It is truly one of the most beautiful places in the city, especially at night, when the Met Life building flashes a different color each evening.

I am listening to a Harvard Professor's lecture about the **architectural** imagination. The first point he discussed was perspective and the importance of the 'vanishing point.' This is the spot where two parallel lines converge at the point of infinity.

I thought, "Huh, that's kinda like life and the people we meet."

The Vanishing Point

Life is a collection of moments
Connecting and existing
A winding road
Of kindred souls
That plot the graph of living

Truth be told, people come and go
At different points and times
We meet
We part
Begin again
Then continue as parallel lines

Every so often
A luck of the draw
We meet some souls that suit us
Gloves that seem to fit just right
As if fate introduced us

For a while lines collide
The perfect intersection
But the push and pull of life itself
Says, "This cannot be lasting"

And so, we plot the point
Go on our ways
To never meet again
Two parallel lines
Can never touch
Just continue on ahead

We chase a chance encounter
The re-crossing of two paths
But such a point—impossible
For this life on which we're graphed

However, there is hope
An inkling of felicity
Two parallel lines
Can meet again

When they converge at the point of infinity.

Connection Points

CONNECTING THE DOTS

As humans, it is in our nature to make connections with each other and with the world around us. We are biologically wired to be *really* good at connecting the dots. Humans are infinitely curious beings; hard-wired to crave understanding and seek out answers. We're riddled with the existential longing to be constantly "in the know." *Mankind demands an explanation for everything.* This element of the human condition has led to some of the most influential discoveries in our existence. Scientists and inventors throughout time have started out with the same two questions: **Why and how?**

More specifically: *Why does this work? And how does this work?*

For centuries, we have taken the world apart and laid out the pieces. As a whole, humanity has obsessively studied the connection of everything in the quest to simply figure it out. This has led to various immense achievements in understanding the science of our universe and harnessing that knowledge to create technology, medicine, transportation, appliances, and a handful of other everyday things that make up the world we live in today. The inherent need for an explanation of our world and how it works is the sole reason why I can type this paragraph on my laptop. It's why you can turn on a light, get in your car and drive down the street, and flush your toilet. *This all had to start somewhere.*

Well, it started with curious people asking questions, connecting the dots, and seeing beyond what was right in front of them. It all began with people looking further into the reason why things are the way they are and making the connection between seeing and understanding.

Humans began making the connection between reality and mentality.

The connection points of life extend far beyond science and invention. They extend far beyond natural curiosity. They trickle down into our everyday moments. As we go on living, reality tumbles us along, presenting us with situations that leave us scratching our heads or crying out our eyes or full of furious rage. We find ourselves asking: Why is this happening? Or how did his happen? *Then, we connect the dots.*

On a larger scale, our personal life is one giant web of connection. Remember, *everything happens for a reason* even if we don't see that reason for quite some time.

However, when you learn to start making connections, you can see how everything up until a particular point has played its role in getting you to where you are right now. Every moment, person, and action has a reason. The connections in reality that happen between then and now will lead you to a present moment of understanding. They lead to the bigger picture, the "why" it all happened, and the "how" it played out.

The connection points of living are a collection of minute happenings and everyday coincidences that capture our attention and somehow end up making sense. They are tiny little everyday validations, formally known as "signs." They form a chain reaction of happenings that guide you down a path. This path makes no sense while it's happening, *until you reach the end point.*

Here's an example: One day, you say to yourself, "I really need to start reading more, but I never have the time." The next thing you know, you're walking by a book shop that's **coincidentally having an impromptu sale on "books for people with no time."** Huh, that's funny. You might pay it no mind and keep walking. Or, you might walk inside and buy a book. You decide to buy a book. The next thing you thing you know, your passion for reading has been reignited. You decide to read another book but don't know which book to read. Then, **you bump into an old friend**, someone you haven't seen in years and they're **carrying a book**. It looks oddly familiar but you can't seem to remember how you know it. You ask them about it. The book they happen to have is the **same book your grandfather used to have sitting on his nightstand**. You immediately buy that book. You start reading. The phone rings. **It's your grandfather**. He's old and has dementia now, but from time to time he'll remember to call you.

He says, "Do you remember that book I used to have sitting on my nightstand?"

You smile down at the book in your lap and reply, "Yes. Yes, I do."

Had you not hit every point, would you be able to say yes to your grandfather?

This is the power of connecting the dots and being able to look back on a situation and say, "Yeah…everything really did happen for a reason." **Pay attention to everything that happens around you.** If you ever find yourself in a situation that doesn't make sense, take a step back and connect the dots—I promise they will somehow form a picture.

Connection points can also serve as validation that we're on the right path. They're like little checkpoints that remind us that things are happening as they should. During my poetic journey, before and after *Out of Chaos* and into *The Aftermath of Unrest*, my odd connection points were **coffee shops**, **architecture**, and **roses**.

THE MOST EXTRAORDINARY STORY

If you've read *Out of Chaos*, you'd be well aware of *The Inverted City* and the Artist. You'd know how both of them were a catalyst to my poetic quest. If you haven't read it and you don't know, let me sum it up:

One evening, after wandering the city for a few hours, the Artist and I ended up sitting at the fountains at the Seagram Building on Park Avenue. I shared two of my most personal poems with him. He was the first stranger I'd ever read to. A few days later, he painted a beautiful image of **two people** dancing—appropriately named "**Sonder** on Park Avenue." Something about the piece sang to me and I wrote a poem to the painting called *The Inverted City*. It's about the *two people* in the painting and the moment we shared that evening. He inspired me and encouraged me to continue writing and sharing my work. If I hadn't met him, *Out of Chaos* would not have become what it did. That's why that particular moment in time, the Artist, the painting, and the poem are all extremely important elements of my poetic journey.

The most extraordinary story of connection points, poetry, art, and fate begins with our first conversation. As we walked down the street, he explained to me how **architecture** played a role in his life and artwork. This seems like a small detail, something that usually gets passed over in conversation and one that would never make sense in the larger context of things. Any other time, that's exactly what it would be. That is not the case

in this story. **Architecture** has always been a connection point throughout my life. It always seems to pop up at pivotal moments.

For example, when I was unsure about where to move in Manhattan, I found myself sitting at a park overlooking the East River across the street from an apartment. A man came over to me, sat down, and we sparked up a conversation about the neighborhood. We talked about life in the area and how beautiful it was to live near the East River. I explained how I wasn't sure if I should move to the area. After a few seconds of silence, he replied, "Do you like **architecture**?"

"Yes" I smiled.

"I'm an **architect**!" He grinned and pointed down the street. "The buildings all around Sutton Place have beautiful architecture. Take a walk around the block. Look at all the buildings. You'll fall even more in love with the neighborhood."

He was right. I signed my lease three days later and I've lived here ever since. This is only one example, but you get the point:

As soon as the Artist brought up **architecture**, I knew he would play a significant role in my journey.

However, I had no idea how extraordinary his role would become.

More on that later. First, let's go back in time...

One cold winter night, Tonii and I were having a meeting at my favorite **coffee shop**. On this particular evening, we were discussing the layout for *Out of Chaos* and brainstorming cover options. I had a few wild ideas but none of them seemed to be quite right. As we were going back and forth, he opened his iPad to show me some of his design ideas. The image he had for his background caught my eye.

I blurted out, "Tonii what's that!?!? It's so cool! It looks like the sun!"

He laughed and replied casually, "Oh, I made that."

We both looked at each other as if the same hand smacked us the head. That was it. That was the cover. It was perfect.

"I didn't know you did art!" I exclaimed.

"Yeah. It's line art. I originally went to school for **architecture**. I wanted to be an **architect.**"

DING! DING! DING! **Connection point number two.**

Fast Forward to February, a week before Out of Chaos Releases

It was around 9 pm and I was pacing back and forth around my room. We were a week shy from the official launch of *Out of Chaos* and I was a restless mess—nervous, tired, and over thinking *everything*. I decided to go to the gym to run off my anxieties. The gym is on the corner of 53rd and Lexington, a block from the fountains on Park Avenue.

It was a freezing evening and I *should have* walked right to the gym. I didn't. For some odd reason, I felt compelled to keep walking. As you know, I've learned to never pass up my intuition. I went in the direction of the fountain because it's a good spot to sit and think. On my way down the street, the thought crossed my mind, "I wonder why I feel compelled to go here. Maybe there's some sort of sign there that will ease my mind. Something to help me know I'm on the right path..."

Well, dear Reader, God listens. The universe hears you. Angels answer. Stars align. Numbers add up. Whatever you believe—*if you ask, you will receive*. I asked for a sign and this is what I got:

In the center of both fountains there were **two people.**

As I turned the corner, I caught the man getting up from one knee. He was proposing! If I had been a second later, I would've missed the moment and I never would have known. How's that for perfect timing? I noticed there wasn't a single person in sight. They were the only people there and no one was around to capture their engagement. *Except for me.* I decided to hide behind the fountain and snap some pictures. The plan was to surprise them with the candid photographs. Besides, it was all too beautiful to leave undocumented. They hugged, kissed, and danced around as the fountain sang its never-ending symphony. I watched from the behind the curtain of falling water, smiling, as my poem *The Inverted City* came to life before my eyes. **Two people**, I smiled at the thought. I thought of the painting and I thought about the Artist.

After they were done celebrating, I walked over to them.

"Excuse me! Did you guys just get engaged?" I asked.

"Yes!" The woman squealed.

"Congrats!" I replied, "I noticed no one was around taking pictures. I took some! Do you guys want me to take some more photos for you!?"

They were ecstatic—totally dripping with love and excitement. I loved it. We had an impromptu photo shoot in front of the fountains. When I was finished taking their photos, we huddled together to take a look. They began telling me about how they met at the fountain when they were in college. It was beautiful to think how Park Avenue was special to me in a totally different way. My heart panged in my chest. All at once, this wonderfully unexpected chance encounter had both distracted me from *Out of Chaos* and reminded me of it. Oh, the duality of moments.

"That's beautiful that you met here!" I grinned.

I was about to start telling them about *The Inverted City* when the women chimed in, "Yes. We met here while we were studying because both of us love this building. It's our favorite one in the entire city because we love the **architecture**. We're both **architects.**"

"Amazing," I shook my head in disbelief. Two architects on Park.

Hello, **connection point number three.**

I knew that moment was the Universe's way of letting me know I was on the right path. It was freezing and I knew we couldn't stand there much longer, so I quickly explained to them the story of *Out of Chaos* and *The Inverted City*. After all, they were the real life couple in the poem. This moment not only validated the direction in which I was headed, but it showed me that even the most personal of pieces can mean something for someone else. That is the power of poetry—*it can make people connect*, with both words and moments.

As if the angels hadn't answered my call for sign with the **two architects** on Park, something even more serendipitous happened the very next morning. Remember the **coffee shop** that Tonii and I were at? Well, I hadn't been there in a few weeks. My morning routine had gotten all jumbled up during the final weeks of launching *Out of Chaos* and there was never enough time in the morning to stop for a coffee.

During the summer, I went to that coffee shop *every morning* before work. They have the world's greatest vegan banana bread and it's my guilty pleasure. Usually, I would buy a slice and a cold brew and bring it with me to an outside table down the street (except for when it rained). On one particular morning in July, it was downpouring. I decided to sit in the back room and read before going into work.

The back room of this **coffee shop** is full of different antique seats. There are big elegant arm chairs, satin couches with small black ottomans, and

coffee tables scattered around the room. A large black bookcase covers the back wall, full of unread books waiting to be grabbed off the shelves. I sat down in one of the extravagant arm chairs next to a petite blonde woman.

She smiled at me and I said hello. We struck up a conversation and she told me about her dreams of being a professor, traveling to Germany, and eventually moving into the City. I told her about my dream of writing a book and overcoming my fear of sharing my writing. As we were engrossed in conversation, I glanced down at my phone and noticed that I was late to work. I jumped up, shook her hand, and said, "Good luck with everything!" before running out the door.

On July 7th, that conversation was just another moment in time. A wonderful random chance encounter. An unexpected heart-to-heart with a stranger. A beautiful, inspiring interaction. I never thought I would I see her again.

Seven months passed.

Now, we're back to the morning after the two architects on Park.

For the first time in a long time, I had enough time to stop at my favorite coffee shop. Not only that, but I felt like I had to. It was almost as if my mind was set on going there *even before I knew I would have the time to go there.* I stumbled inside and the door jingled shut behind me. I bought my slice of banana bread and headed to the back of the café. Guess who was sitting in the same chair as the morning we met? The same woman. We immediately recognized each other. I sat down next to her and we started excitedly chatting about running into each other again. It was like seeing an old friend even though I'd only met her once. She explained to me how she hasn't been to this coffee shop in months, but on this particular morning, something "told" her she had to come. I laughed and said the same thing happened to me.

"Wow," she smiled, "Guess what? When I returned from Germany, I got the job as a Professor, and now, I live down the street!"

I smiled back, "I wrote my book and it comes out next week."

We both did exactly what we said we were going to do. *Full circle.* Yet again, the universe found a way to let me know I was exactly where I needed to be. This is why it's important to keep your eyes and ears open to the world at all times. The universe is constantly sending us messages that we're on the right path. But, if you don't pay attention you'll end up missing them. Connection points and full circle moments happen all the time. *They are everywhere.* I'll say it again: **you have to pay attention.**

The connection points of living and the connection of people do two things. They validate our path and remind us that what goes around always come comes back around. When it does, it will somehow always end up making beautiful sense.

But, it doesn't stop there.

The story is about to take an *extraordinary* turn.

However, we're going to have to do a bit more time traveling before we can get to the ending.

Hang tight.

Let's shoot forward in time.

We're at the East River Esplanade on 34th Street.

When It Rains, It Pours

It poured all day. The sky was angry and dark grey. The wind howled and shook the windows. The sadness of COVID-19 felt as heavy as the rain drops falling from the sky. It seemed as though the sun would never show.

But, it did.

The sky faded into a brilliant blue and the clouds rolled away. The sun shone bright and strong. People came out of their homes. This was good. This was happier. For a second, it felt almost normal... except...reality check: *everybody is wearing masks.*

Sigh.

Games With Sanity

I am a game of Jenga
Each thought, its very own block
Perfectly placed
Ready to pull
The game
Ready to start

One block is happy-go-lucky
Another, it's time to grow up
One block is madness, another is sadness
Together they neatly stack up

Playing this game against me
My worthy opponent—insanity
In order to win, I have to be smart
Approaching each pull with a strategy

Until I catch on that it seems to choose
Without a reason or rhyme
Pulling the blocks
And adding to the top
As my unsteady stack slowly climbs

Now, every pull is calculated move
My quivering hand feels disabled
I'm forced to choose only blocks misused
At the risk of becoming unstable

Slowly, I wobble and sway
Face unavoidable tragedy
I'm seeing this truth
That it's easy to lose
When also against me—reality

One wrong move
I'll falter
The slightest tap
I'll fall
But I refuse to lose this game

So, I continually pull…

We're in Sutton Place, wandering up and down the street.

Restless Evenings

Tonight is one of the nights I will not be sleeping. Thankfully, Sutton Place is one of those places that's safe enough to wander at all hours. It's fancy neighborhood on the east side of Manhatan and the perfect place to spend a restless evening.

The buildings have beautiful **architecture**, the streets are well-kept, and there is always a security guard lingering in the doorway of the high-profile apartment buildings. There is a small, quaint park that sits at the end of the street adjacent to the highway. It is lined with benches and bushes, and in the Spring and Summer it overflows with **roses** and tulips.

I take a seat on one of the benches under the moonlight. I had too many cups of coffee and my heart is racing in my chest.

I light a cigarette.

I feel anxious.

I feel alone.

I feel.....

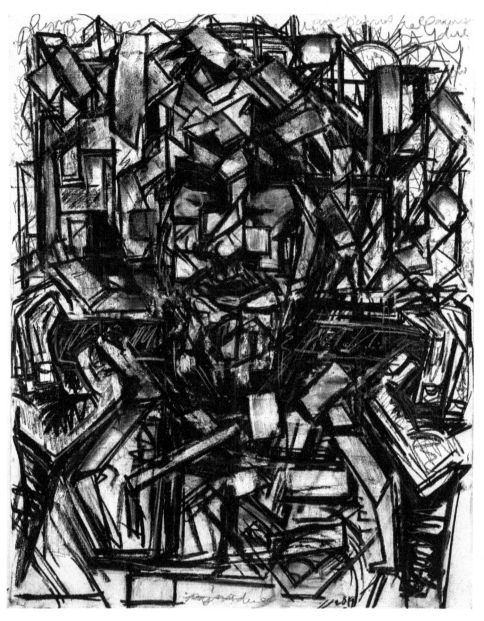

"Self Portrait 04: Rent," Acrylic, charcoal on canvas, 24 x 30 in., 2019. Artist: Grant McGrath.

Trapped

Fueled by caffeine and nicotine
Losing my battle of selves
Staring at endless insecurities
I've maniacally ripped off the shelves

I take a step back, and study
The ugly, beastly pile
Towering high before me
Disgusted, I choke back my bile

Sickened
I turn to flee and find
I'm trapped behind a wall
The bricks are my doubts
The cement is my sorrow

I climb it's too high and I f
 a
 l
 l

"Let's try this again!"
I cry to my selves
My fingers cling the brick
I fight to hold on
With weakened hands
Albeit my breathless distress

As I scale my own insanity
A self-made wall of woe
I face the choice to keep hanging on
Or give up, give in, and let go

I continue to climb
Despite my despair
And although it's a strenuous task
I've always considered my resilience

The skill that will strengthen my grasp.

We're at a dead-end underneath the Queensborough Bridge, overlooking the highway and the East River.

Breakfast with the Birds

The weather is just right—sunny and mid 60's. There is only the slightest breeze, but it's warm enough to leave my jacket stuffed inside my bag. The city has just started to come back to life. There are a few people wandering the streets and a good amount of cars are rushing by on the highway below. The faint sound of on-going construction lingers in the background.

The sun is beating down, mighty and warm. *It feels normal.* I reach down to grab my crumb cake.

"Everything is going to be okay," I sigh.

A bird lands at my feet and pecks away at the fallen crumbs. I start thinking. *Over thinking.* I laugh to myself, *"Huh, kinda funny how crumb cake rhymes with ruminate."*

Crumb Cake And Ruminate

Rising sun
Morning dew
The essence of wondrous sky
I gaze into the painted clouds
Interrupted by my mind asking, "Why?"

A long, slow pull from my cigarette
Staring out at the sky
To contemplate
"It's a beautiful day for breakfast outside
Iced coffee and a slice of crumb cake"

The stale taste of tobacco lingers
Lost in thought, I chew
Suddenly stuck with decisions
And it seems

I don't know what to do

An invigorating rush of nicotine
This cigarette cuts the sweetness
At war with my thoughts
And not thinking straight

So, the cake on my plate becomes tasteless

These thoughts are hard to swallow
Unpleasing and obscene
I chew them slow
Then wash them down
With icy sips of caffeine

The coffee is strong and bitter
Yet, the sugar coats my lips
How'd this meal
Once pleasant
Become a breakfast of regrets?

"It makes no sense!" I cry
Crumbs tumble from the table
How'd I go from "Rise and shine!"
To chaotic and unstable?

I guess this is my breakfast
Consuming this sickening cake
So, I sigh and endure the last few bites

Til' rumination clears my plate.

We're walking down 86th toward 1st Avenue.

Madness Strikes

It's cold, it's dark, it's late.
Madness.
Madness.
Madness.
Pure Madness.
I hate everything I've written.
Writing a book is a stupid idea.
I'm a bad writer.
It's never going to happen.
Nothing is falling into place.
I don't know what to do next.
Please, send me a sign!
This is stupid. I am stupid.
Delusional.
Why is it raining?
Why don't I have an umbrella?

Unaligned Chaos

Heart and mind
Unaligned
I'm searching for a sign
Screaming from the inside
No, not this time, I'm fine!

Or am I?

The words have left me
I am blank
Beaten down and broken
Maybe it was best, I think,
To leave the words unspoken

Every letter ever written
Stings my eyes and ears
Sliding down my face
Burning my cheeks

Literary

 Acid

 Tears

They've up and gone away

I'm standing here, abandoned
My poetry foreclosure
Empty pages

Strewn and stranded

Lost without a compass
Rapid mind repeating
Blindly running
Heart on fire
Erratically beating

Out of pace
Out of place
Heart and mind run wild
Simply speaking
I am in sinking
And need to reconcile.

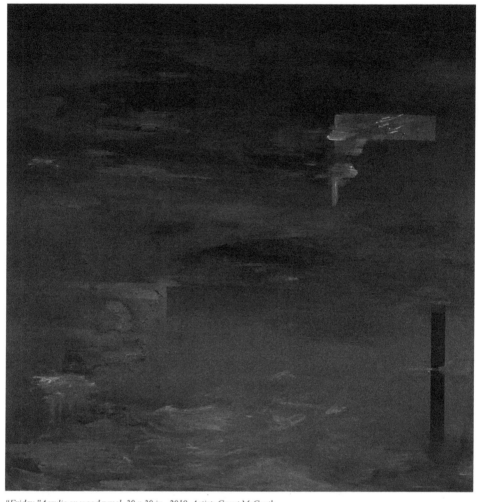

"Friday," Acrylic on wood panel, 30 x 30 in., 2019. Artist: Grant McGrath.

We're at Sutton Place Park.

Sunrise in the City

It's a freezing Winter morning.
The sun paints the sky crimson.
The clouds rest gracefully above the Queensborough Bridge.
The icy breeze gnaws at my cheeks.
Cold winter chill.
Fire orange skies.
False perception of self through the reflection at the rivers edge.
Frozen hands.
Racing mind.
Stiff knees.
Weak legs.
Fast heart beat.
My soul...
My mind...

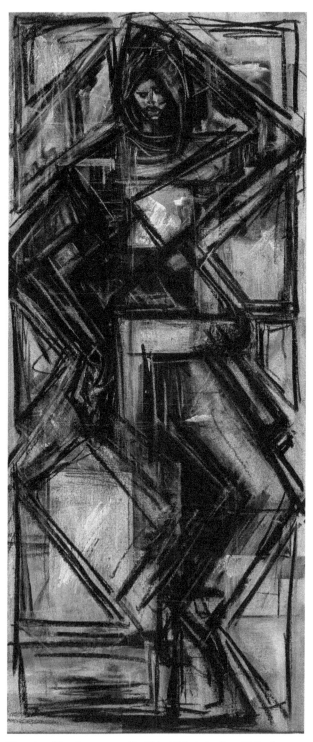

"Portraiting,"Acrylic on canvas, 12 x 28 in., 2019. Artist: Grant McGrath.

My Body, Personified

Shouting from the cotton
Embroidered on my sleeve
My heart screams through the threading
"Please just love me, please!"

Through the cage inside my chest
Squirming in its seat
My wild soul sits restless
Begging to break free

Behind my skull, a twisted brain
Sorting through emotions
Filing chaotically
To organize commotion

But it can't

Within my skin, the web of veins
Wrapped around my bones
Pulses information
From twisted head to toes

My weakened knees and tired legs
Wobble as I saunter
Walking forward should be easy
So why is this task so daunting?

It should be "oh so simple"
But, I can't get it straight
I walk the line, unbalanced
Heart and mind

The endless race.

We're pacing up and down 52nd between 1st and 2nd avenue.

Inside My Mind

Why can't I write anything that means something?
Why am I even writing at all?
Who am I even writing for?
Why am I doing any of this?
When did the words lose their meaning?

W h e n

d i d

t h e

w o r d s

l o s e

t h e i r

m e a n i n g ?

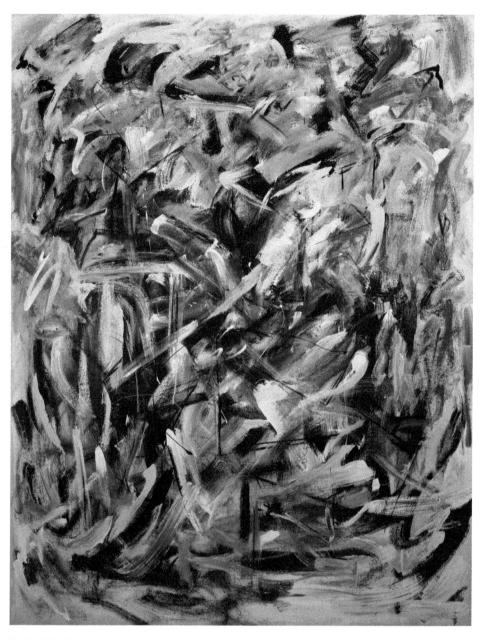

"Release,"Acrylic, charcoal on canvas, 54 x 70 in., 2019. Artist: Grant McGrath.

Reoccurring Restlessness

When did the words lose their meaning?
When did they stop making sense?
When did my form turn to capture?
When did present become past tense?

When did the words lose their magic?
Muddled and lost on the page
Writing once fervently freed me
So when did it start to encage?

I force the words with empty thoughts
The purpose, unbeknown
Tirelessly faced with the question:

For whose sake, if not my own?

Once the release that helped me sleep
Is now my restless curse
Writing without a meaning
As the ink now runs perverse

If not for me than who?
These words, they've been declared
Yet they reject the ears they fall on
As if they've not been heard

Nothing suffices the need, I scream
Who are they for? I ask
An existential crisis
Pleading to the pen—*I now detest*

Where is the liberty of literature?
The bliss of a beautiful word?
The solace of a well-crafted sentence?
And the joy of an eloquent verb?

I miss the salvation of verbiage
The unfettering that accompanies my pen
Maybe if I work out the meaning
I can write myself free once again.

We're at the top of my stairs, in front of the door to the roof.

Sorrow

It's pouring outside and the weather matches my sadness almost too perfectly. I have just received news from a friend. It's not good news. It's the worst news.

I am consumed by immense sadness.

The goal is to always remain hopeful but when faced with inescapable and unbearable sorrow, the urge to vanish is all consuming.

I want to disappear.

I want nothing to do with any of this.

I want to...

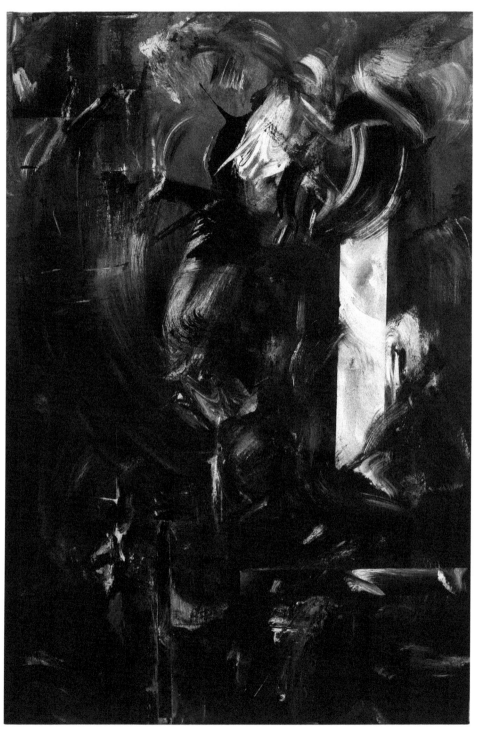

"Spring,"Acrylic on canvas, 24 x 36 in., 2019. Artist: Grant McGrath.

Evanesce

I dream of disappearance
A beautiful evanesce
To become a ghost of yesterday
Nameless, first and last

Erase me like the chalk board
Nothing left but dust
Remnants of my presence
Just a cloud of "who once was"

Eliminate the evidence
And leave no trace behind
Dip the sponge and wash it clean
My faded, pale lines

I dream of screaming, rising steam
Jealous of how it dissipates
I envy the ability
To exist and then evaporate

To be a falling snowflake
A moment, come and passed
Here for just a second
And then, melting in the grass

You see, I dream to simply vanish
Pass out of sight immediately
This sadness is unbearable
And I face it inescapably

With promise of tomorrow
Despair can be escaped
And after sorrow settles...

Have hope, that joy awaits.

We're walking down 1st from 82nd street.

The Mind is a Madhouse!

Late night wandering is always a great way to settle the chaos in the mind. It's definitely not the safest, but it's the most effective (for me at least). There's something special about walking down the street in New York City late in the evening. Everything is still alive.

Wild.

Electric.

Spontaneous.

Around every corner, there is something new and exciting. At all hours New York City is like a circus.

Much like the mind...

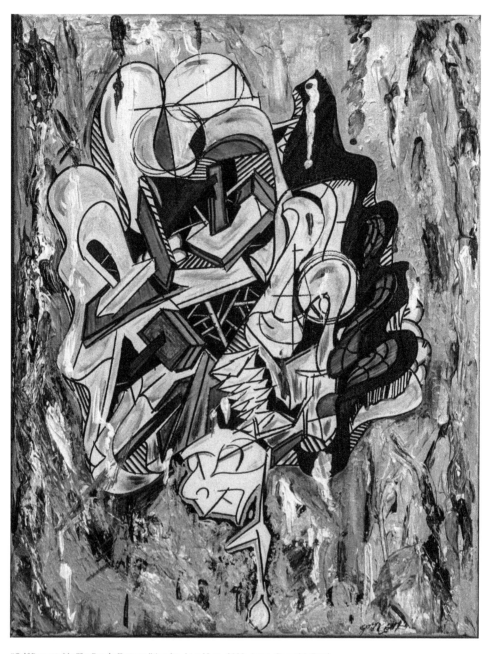

"Self Portrait 01: The Puzzle Factory," Acrylic, 14 x 18 in., 2015. Artist: Grant McGrath.

Circus Psyche

Bottled up
About to burst
Spinning around in circles
Trying to make sense of it

But my mind is like a circus
Without a ring leader

This circus is in chaos
The clowns have lost their joy
The creatures out of order
Cannot perform so they destroy

Every monkey runs amok
The lions—loose from cages
Elephants have broken free
And crushed the plastic stages

The tent is droopin
Each pole is leaning
The clown car has a flat
The animals run wild
As the lions plan attack

The bearded lady is shaving
Contortionists unfold
The ticket booth is empty
As not one seat has sold

Circus psyche
In a frenzy
Flustered
Mental torture
I need to be the ringleader
Somehow, restore the order

But I need help to fix this mess
Too large of an endeavor
So, I call upon a friend or two
To put things back together

We round up all the wild beasts
Mend the fallen tent
Re-captivate the audience
Revive the grand event

Boisterous cheers and laughter
As the crowds come filing in
Order restored in my circus mentality

So a brand new show can begin...

To this day, the best metaphor I have ever used to describe the anxious mind is a circus. It is an absolute freak show. A free-for-all. A ticket-less event that is totally out of control. There is no ring leader—just wild animals running loose and wreaking havoc. *Racing thoughts are maddening.*

How does one round up all the animals and restore order? Well, this might be an oxymoron but the only way to reel them in it to release them.

Set em' free by speaking them out.

You have to let the lions loose from the cages of your mind and into the world as words. Are you picking up what I'm putting down? If not I'll state it more clearly:

Talk about your thoughts.

Do not be ashamed of the madness.

Say it.

Speak it.

Shout it from the rooftops.

Once you speak them out they're a lot easier to deal with. Sometimes, the best thing you can do is hear yourself say what you're thinking. Once your thoughts are tangible, as in, actual sentences spoken out loud, it puts them into a new perspective. Hearing them out loud allows you to hear how irrational they truly are. That's why therapy is good. No, *great.* It's spilling all your thoughts to someone who doesn't even know you. At first, I was in denial about therapy. Me? No way. I don't need therapy. Then, a good friend said to me, "Natalie, just go. Therapy is like taking a huge emotional sh*t." She was so right. Clearly, I was constipated.

Too far? Oh well. I went there.

Anyway, talking about how you feel, OUT LOUD, is the best way to make to sense of things. It's totally eye opening. It feels amazing to just *get it out.* Trust me, once you get into the therapy groove it's like uncontrollable

word vomit. Feelings start pouring out of you like a broken faucet and it feels wonderful.

If that doesn't sound like the best thing ever, you also get another great thing from therapy: an outside, objective opinion from someone who isn't judging you. Oh, and they have a PHD which means they know what they're talking about when it comes to solving the brain. Basically, a therapist is *really good* at making you feel a little less crazy.

But hey, it doesn't always have to be a therapist! You can get those feelings out in other ways too! You can talk to friends. Strangers. Hell, even yourself in the mirror. You can write them, sing them, or draw them. Possibly dance them out while singing them backwards? Scream them into your pillow? Yell them at the wall? Whatever you choose, *getting those thoughts and feelings out of your brain is a game-changer.*

Speak the thoughts. Hear yourself. Set the madness free from your mind. *Set yourself free from your mind.*

Alright, back in time we go! It seems appropriate to go all the way back in time to...**therapy.**

My Therapist's Fish

THIS STORY HAS A POINT, I PROMISE

Let's talk about Doctor Black.

All you know about Dr. Black are a few simple facts. The first, that he's one of the four people that *Out of Chaos* is dedicated to. Apart from all of my other daily woes, he listened to my poems every week as I was writing Out of Chaos. Not only did he give me weekly "validation," but he incessantly persisted that my poems were "special." Still to this day, he's psychologically analyzed and vetted every single one and that's definitely above his pay grade. What you don't know is just how much fate played a role in the entire story of me, "DB," and poetry.

Smack dab in the middle of my mental crisis, my coworker suggested that I try a therapy. I instantly rejected the idea. The thought of talking to a therapist had never crossed my mind. I didn't think I would ever be in a place where I needed it, let alone, I had never imagined myself sitting across from someone while they analyzed my feelings. Yikes. The very idea terrified me and I had no idea what to expect, but at this point, I was out of options and I needed help.

The only problem? At the time, there were no available therapists in Manhattan. After all, it's New York City. Everybody goes to therapy (which I didn't realize until way later in my mental health journey). I downloaded Zoc Doc—an app that assists in finding doctors—and trolled every office in Manhattan with zero luck. It's important to note that when it comes to therapy—it's not just about finding any doctor willing to take you. You have to make sure it's a good therapist. Someone that works for you. Why? There is nothing worse than a bad therapist—trust me, they can do much more harm than good.

Excuse my French, but I was shit out of luck. The process of finding a therapist is definitely not easy. Thankfully, the same coworker who suggested it in the first place, ended up offering me the number of hers. I had nothing to lose so, I called him immediately. After a few hours of phone tag, he finally got back to me, saying that I was "lucky because he usually has no openings." By chance, or way of fate, he just so happened to have an available slot the next day.

Just like that, my first ever therapy session was scheduled. Again, yikes.

THE LAND OF THERAPY

Dr. Black's office is exactly what I imagined it to be, as in, it's the epitome of what a therapist's office should look like. The layout is an old apartment that was converted into an office with a small, white room and a single hallway full of doors. The white room has a tiny seating area with a few chairs that line the perimeter. On one side of the room, there is a large painting of a vase full of pastel, oddly shaped flowers. Across from it is another painting of a meadow. Average, old school, doctor's office decor. There are two coffee tables wedged between the chairs, stacked high with magazines and the other with old mail. The rug is Victorian style and runs around the room and down the hallway, stopping just before the door at the end. My guess is that it's supposed to be bright and welcoming. It's not.

When I walked in, I wasn't sure if I had just entered a horror movie or a hallmark movie. It could've gone either way, really. I sat down in that chair, completely on fire and stared into the flower pot painting, trying to silence my chaotic thoughts. I was sitting on pins and needles, not cushions. The air felt thick and unbearable. The white walls melted together and blended into the carpet. The paintings morphed into giant smudges and the room became a whirling blur.

Dr. Black walked out, called my name, and I got up and followed him in. His actual office is a snap shot out of a movie set for Therapy 101. The room is dimly lit and accented with dark furniture. A massive mahogany book case covers the entire back wall. In front of it, a single black leather arm chair. It's worn and clearly has been there for entirely too many years. That's DB's spot.

On the opposite wall, there's the matching leather couch—equally as old and worn as its arm chair counterpart. A large picture frame that contains an image of cows on a hill hangs above it. Directly across from Dr. Black's armchair, and diagonally facing the couch, is another leather chair with a single pillow. That's my spot. The edges of the chair are picked away. The leather is tattered, probably from countless nervous people scratching at

it as they work out their frustrations. To the left, there's an odd lamp that looks as if it was made from human skin. (I wish I was kidding, I even asked him. For the record, it's not.) Finally, in the back of the room, a wooden desk scattered with paperwork and pens.

In the first five minutes it was evidently clear how bad I was at "doing therapy." So obvious, in fact, that after I finished talking, Dr. Black blinked and said, "You've never been to therapy before, have you?" To which I replied, "That obvious, huh?" The first session was a disaster. He reassured me that it takes a few times before it gets better, but I was totally out of my element. I left with racing thoughts, "This isn't going to work" "This is stupid" "What does he know?" "I'm doomed."

Something inside me told me to go back. So, I did.

The second time I went, I noticed he had no certificates or degrees. The walls in the room were lined with framed pictures of cows and landscapes photographs of Scotland. There were no credentials. No proof. This guy seemed like a total fraud.

I sat down and blurted out, "Are you even qualified???"

He laughed, "No, I'm just an old Jewish guy who sells sandwiches and you're mashugana!"

I burst out laughing and dropped the act immediately. I felt comfortable. In turn, all of my problems started pouring out like a broken faucet. After that, therapy was a piece of cake.

A month or two went by and life was getting a little bit better with each passing day and every Monday evening session. A good therapist will get to the root of all anxieties, even the ones you're not there for. That's how poetry made its way into our conversations. On this particular day, my imposter's syndrome was the topic of the hour.

He started joking about how I should write a book about therapy. I laughed it off and thought nothing of it, but when I left his office that day, an idea popped into my head. I wrote this:

My Therapist's Fish

You've heard of the fly on the wall,
But, have you ever thought about the fish in the room? I bet you haven't.
It's a mindless subject, really. Nobody ever thinks about the fish. It's just
there. Floating around. Spitting bubbles into the water. But fish have ears,
they have eyes, they have minds. They hear and see like the rest of us, but
their knowledge is kept in utter silence. The fish in the room not only has
its gills, it has your secrets too.

Inside The Bowl

The people in this room. They come and go, they talk. They flail their
arms as the therapist bats his eyes. They grip the old leather arm chair
and squirm in their seat. Each person is different than the next, but
they're all the same, really. They're all troubled. They're all lost in their
minds, or losing their minds, rather. I hear and see it all. Trapped in my
glass world.
They fill my bowl with their secrets.
Unaware of how their insanity is my entertainment.

The concept of an omniscient fish was hilarious. I giggled and bounced
along, writing furiously as I walked down the street—totally distracted
from my thoughts. In that moment, my mind was at peace. The only
thing it could focus on was the fish in the room. I stopped dead in my
tracks. The light-bulb went on. Writing is my remedy.

The following Monday, I burst into Dr. Black's office.

"I decided to write a book of poetry!" I said matter-of-factly.

He blinked and after a long pause, asked, "Well... do you have any
poems?"

"Yes." I shot back.

Dr. Black raised his eyebrows and re-adjusted himself in his arm chair.
He clasped his hands together and said bluntly, "...How can you write a
book, if you won't even share them with me?"

I thought about it for a minute. Weighed my options. Felt the anxiety

bubble in my chest. Then, I concluded that if anyone was going to hear them…it would be my therapist. After all, it's his job to listen to everything I say without judgment. I squirmed in my seat and picked at the armchair.

"You're right."

From that moment on, I started reading all my poetry to Dr. Black.

It ended up being that he had studied poetry for years prior to becoming a psychologist, and in the years following. He had an extremely vast knowledge of poetry. His feedback was valid, not only in the psychological context, but the actual literature too. *What are the chances of that?* There are thousands of therapists in New York City. Not a single one was available while I was searching. Quite frankly, he wasn't either. Yet, I had just so happened to call on the right day at the right time. So tell me, what are the chances that the therapist I ended up with knew everything there was to know about poetry? How does that happen?

Fate. That's how.

My poetic journey had started, even before I knew it. It started the moment I walked into therapy. I went back and forth about whether or not to keep the story about Dr. Black in this book. The decision to leave it in relied on two very important reasons:

1. The importance of therapy

2. Fate

Fate is very important. Some of you may not believe in it, but I'm here to tell you—fate is real. If you don't believe me now, you will. Here's the thing about fate:

If you try to fight it, it will fight back. If you try to run from it, it will chase you. But, if you welcome it—the outcome is always favorable.

See, fate only leads you in the direction in which you are meant to be traveling. Fate keeps you aligned with your purpose.

Very few people are lucky enough to have found their calling. Some of us are on the journey of discovering what it is or what it might be. Some of us are in the early stages of discovering what it even means to have a "purpose." Others haven't even begun the search. It doesn't matter where you stand, what matters is knowing that fate will always step in to get you where you are meant to be. Or so, I like to believe.

There are many things in life we cannot explain, fate being one of them. If you think about it, most success stories somehow always have a common denominator. You guessed it! Fate. You hear things like "The stars aligned and I got the job of my dreams," or "Everything fell into place and I bought my dream house," or "I ran into someone by chance and they changed my whole life." Those sentences are not rooted in coincidence. Each statement is just another way to say one thing:

Fate swooped in to help guide you in the right direction.

There are no accidents. Everything happens for a reason. Maybe that reason is always because of fate in order to get us where we need to be, course correct our lives and align us with our purpose.

But hey, not everyone is a believer in fate and that's okay. I'm not here to judge or force anything on you. I'm just saying...if you don't believe in it now...you will by the end of this book.

Trust me.

Alright folks, lets shoot forward in time.

We're on 53rd street walking towards 7th Ave.

The Art of 'Lightening Up'

It's a mildly chilly winter morning.
Cold enough to bite your cheeks but not cold enough to show some breath. The streets are full of blue suits and yellow taxis, people are scurrying to work, and cars are honking.

This is your typical New York City walk-to-work morning commute.
I notice that everything and everyone is the same.
Blue collars.
Khaki pants.
Black coats.
How wildly boring to be surrounded by such complacent normalcy.
There is a woman yapping angrily on her cellphone waiting for the walk signal.

The music in my headphones is blasting.
I stop next to her and start to dance in place.
She shoots me a judgy stare.

"Poor woman," I think, "She's way too caught up in the risky business of seriousness."

The Risky Business of Seriousness

Skipping down the street:

Erg a derg a loop di doo
La di flergin dah
Wizzle wizzle zingle dee
Ringle rangle rah

Shizzle shizzle zoo zop
Blahbiddy blahbiddy booo
Dingle dangle frazzle dazzle

Derpy derp di wooooo

Chingle changle
Cheesy jingle
Shmergin dergin dah
Doopity dee
Doopity dough
Hoopity hip horrah

Zingle zippity zerp

Passing people
On the move
Pitter patter
This world is a platter

So why not eat the food?

It's a fancy feast
A heaping bowlful of meowmix
Eat it up, enjoy each bite

Or, face the risky business

Of

 taking

 life

 too serious.

We're in my bedroom staring at a candle.

Fire Fills The Iris

"Fire is fascinating," I think to myself, as the yellow tea candle slowly burns. The wax collects around the base in thick puddles. The flame flickers in the wind. The breeze sends a muted cloud of rose and lilac scent into air around me. The soft halo of glowing light stands out against the black of night. There are no lights on in the buildings outside. Most people have left the city, others are sleeping. I am wide awake, engulfed in the fire of this candle; completely transfixed on the flame as it waltzes in the gentle winds of midnight.

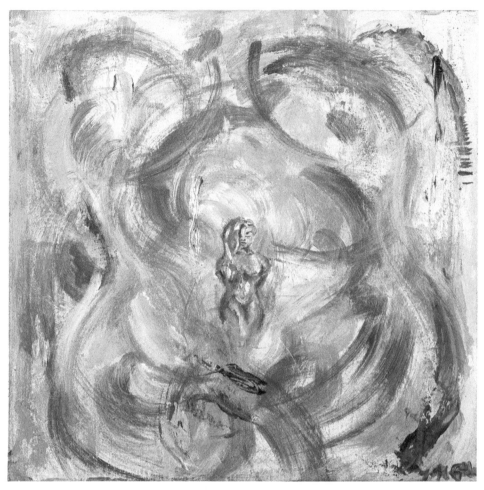

"Sand in the Wind," Acrylic on wood, 18 x 18 in., 2018. Artist: Grant McGrath.

The Dancing Flame

Ignite me in the moonlight
Against the windows pane
The slightest draft, I flicker
I, the dancing flame

For a moment
I am fire
A captivating glow
But the longer I burn, the less I become
So please
Close your eyes
Let me go

But you don't

Me, the burning candle
Distorted by the heat of my wick
A pool of wax surrounds me
Warm
Malformed
And thick

Fire fills your iris
Fixed on my melting mentality
For you, a moment of pleasure
To me, an inevitable tragedy

A candle is lost without fire
And for you, I am the blaze
I'll never know why
I destroy myself
To satisfy your gaze.

We're going up and down and up and down 53rd street.

Pacin' Pacin' Mind Be Racin'

It's April. *April what?* How long has it been? Today is warm. The flowers are starting to bloom. I miss people. I miss coffee shops. *What day is it?* I don't know. Still in quarantine. Still can't go to work. Still can't see my friends. Still thinking a mile a minute. Still don't know what's going to happen next. Still pacing up and down the streets but this time more alone than ever before. Still dealing with the monsters in my mind but this time they're much easier to appreciate.

Mind is spinning.
Why are you the way you are?
Why are you thinking these things?
When is this going to end?
What do I do?
Where do I go?
Oh, Reader let's.....

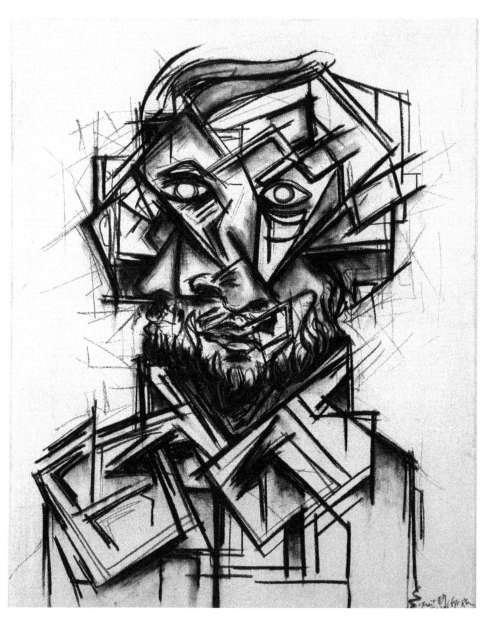

"Self Portrait Seven,"Acrylic, charcoal on canvas, 24 x 30 in., 2019. Artist: Grant McGrath.

Take A Walk With My Thoughts

I am so finished
With constantly thinking
Done with back and forth
But as much as I try to scold my mind
It never seems to shut off

Walking helps and music distracts
Though, my thoughts are creeping creatures
They hide behind a web of lies
Popping out with surprising demeanors

I try to let go of the madness
These ideas that plague my mind
But these little beasts
Are ruthless
And show up at worst possible times

Words are a beautiful music
But they're begged to be used as a weapon
The beasts inside valiantly try
Though my soul knows to use them as medicine

I don't regret this chaotic state
It's part of what makes me, me
Madness in all the wrong moments

Makes me walk with my thoughts til' I'm free.

We're at the top of my staircase in front of the door to the roof.

Words Are Medicine

It's cold outside and unbearably quiet.
I am losing my mind stuck inside.
There is nowhere to go.
There is nothing to do.

Hm, I *can* write.
But, I can't seem to write about anything happy.
The virus is all anyone is talking about.
It's everywhere.
All over the place.
The world is uncertain and chaotic.
It's inescapable.

Much like my mind.

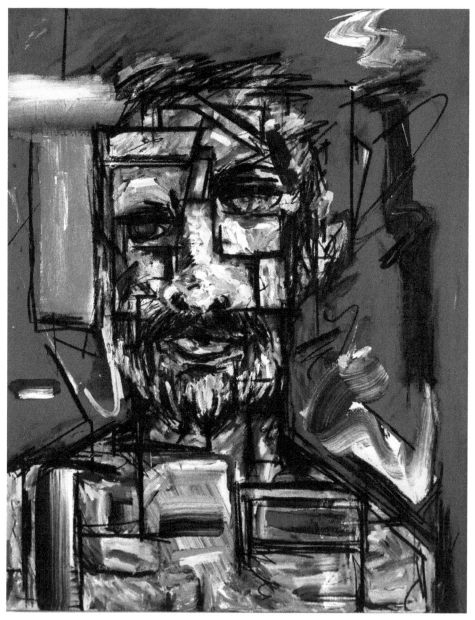

"Self Portrait 08, I am Red," Acrylic, charcoal on canvas, 24 x 30 in., 2020. Artist: Grant McGrath.

Curse of Creative Neurosis

I've fallen ill, against my will
Sickened by my thoughts
Distraught, deranged, demented
Quite frankly, at a loss

Furiously feverish
I fight my feelings desperately
This virus of the mind state
Is spreading too infectiously

Cover my mouth, scrub my hands
Desperately try to contain it
But there is no such saving luck
With this irreparable aliment

Constant unease is a deadly disease
It tortures me obsessively
It makes no sense that writing
Is both the sickness
And the remedy

You see...

Words may sooth the symptoms
But their side effects—neurotic
This condition, a conundrum
Uncontrollable and chronic

Mad as hatter
Wild mind
Maniacal
Sick in the head
Quite possibly, *incurable*
Until I grab my pen

Off my rocker, I'm a writer
My madness is adrenaline
Poetry might poison me

But words, are the only medicine.

We're somewhere in Manhattan.

Where is my mind at?

It is one of those perfect weather kind of days. I'm walking around the city thinking about how much I'd love to write about the beautiful flowers sprouting from the pots that line the streets or the way the sun makes the East River sparkle. I want to write about the wind and how it sways the trees and the gentle breeze that breaks the heat of the sun as it hits my shoulders. I want to write something happy. I can't. I can't write about any of these beautiful things. The world is too crazy. The city is still silent. Everything feels sad so every time I try to write a poem, it turns out to be about....

"All the Feels," Acrylic, charcoal on canvas, 42 x 42 in., 2018. Artist: Grant McGrath.

Something Unbeautiful

I sat down to write something beautiful
I wanted to write from the heart
I wanted to prove that stars could align
But when I tried
I didn't know where to start

I'm dying to write about living
But sadly, I don't understand it
I tried describing a firefly
It flew by
And all I felt was abandoned

I am now empty handed
And I cannot stand it
I don't understand this
I'm begging

Please…

I tried to prescribe myself hopefulness
When that didn't work
I tried faith
When that seemed to fail, I fell to my knees
Not quite sure to who...

But, I prayed

I cried out for fate, no answer
I waited, no knock at the door
Drowning in tears
"I want flowers!"
So why is life handing me swords?

I screamed out for truth
And it answered
"Are you sure? This is going to hurt"
Fed up with lies, too tired, I sighed,

"I know. But, it's time to be heard"

Lessons From Passing Souls

THE WORLD AND ALL OF THE PEOPLE IN IT

The world is full of people and they're all living, breathing stories. Each person has experienced life differently and every person has a different perspective on life. Everyone has something to say and if you're open to listening you never know what might come of it.

As I said in *Out of Chaos*, "I believe that there is no such thing as coincidental interactions. Everyone we meet serves a purpose and everyone comes and goes for a reason." Dear Reader, there is a lesson in everyone we meet. Daily human connections are vital to our growth. Conversations with strangers can change your entire life but *you have to be open to them.*

The Dictionary of Obscure Sorrows defines the word **sonder** as, "n. The realization that each random passerby is living a life as vivid and complex as your own—populated with their own ambitions, friends, routines, worries and inherited craziness—an epic story that continues invisibly around you like an anthill sprawling deep underground, with elaborate passageways to thousands of other lives that you'll never know existed, in which you might appear only once, as an extra sipping coffee in the background, as a blur of traffic passing on the highway, as a lighted window at dusk." This word makes you think about the role you play in the life of a passing stranger. However, sometimes, we break the wall of being a simple "extra." Sometimes, we become a random chance encounter—one that comes with a lesson or gives a lesson. Whichever one it may be, it is always a blessing in disguise.

Out of Chaos was the love child of many chance encounters and fleeting interactions—some lasting longer than others. It's very important to be open to random and unexpected encounters. You'll be pleasantly surprised at what people can teach you in a matter of moments. Sometimes, we don't even notice the relevance of what someone says until a while later. Sometimes, it's exactly what we need to hear in the moment. It's important to *listen* and to perceive every conversation as a message. Don't over think. You'll know when it happens. It can be as simple as daily morning chat with a coffee barista or a five minute conversation with a man on a bench in Central Park:

Old And Wise

Elderly man
Empty bench
A "Hello" I couldn't resist
Alone in the park
We pondered
What exactly it means to exist

I asked,
"What keeps you going?"
He cocked his head and smiled,
"The most important lesson of all

Never lose your inner child"

"Union Square," Acrylic, charcoal on canvas, 36 x 36 in., 2018. Artist: Grant McGrath.

The Song of The Sparrows

"I know everything there is to know
Ask me about the birds
They eat the crumbs
I throw at the them
As the buzzing city stirs

I'll tell you about the city
Each building has a story
Known to me
Like the back of my hand
As if it was my diary

I know history
And science, too
I'm a master of mathematics
I sit here and I feed the birds
To soothe my endless madness

What's that you ask?
It's loneliness

Then I meet a soul like you
Seeking information
And all my unused knowledge
Comes out in conversation

See that bird?
The starling
And that right there?
The sparrow
Knowing this seems useless
But just look at that little fellow

The tiniest bird among its peers
A symbol of simplicity
Yet—a blanket of protection
When they move
As one small symphony

Always in a clan
Small, but large in numbers
They teach a powerful lesson:
That together, we're much stronger."

I stand
Shake his hand and ask:
« Will you be here tomorrow?"
He cocks his head and smiles,

"I travel with the sparrows"

ALL IS NOT LOST

Passing strangers are the teachers in the world that go the most overlooked. Someone recently said to me, "Natalie, God works through people." It's the truest thing I've heard in a very long time. Trust me, you'll be surprised at what you can learn from a simple hello.

You never know how much a person can end up impacting your life.

This is another reason why the world and all of the people in it are my greatest source of inspiration. Sadly, the pandemic had forced us all inside,\ and everything felt...lost. The magic of meeting strangers and finding inspiration was gone. The lingering sadness of lost moments was haunting. The world was silent chaos, coupled with my the mess inside my mind and the staggering uncertainty of reality. Hope was fading and it was taking inspiration with it. The sense of magic and oneness with my surroundings felt completely lost. Life felt so...*unbalanced*. This overwhelming discontent was too much to bear. One day, I decided to retrace all my steps in hopes that I would find what had gone missing.

Why? Well, it's a rule of thumb that when you lose something you're supposed to retrace your steps because you're likely to find it in a spot somewhere between where you were when you lost it, and where you ended up. If not, chances are it's gone for good.

That is, unless fate somehow brings it back to you.

It was beautiful Saturday morning. The sun was high in the sky and people were flocking to the streets; trying to soak up as much Vitamin D they could before going back inside. I set out on the existential quest to find whatever was missing.

Where did I end up? Central Park.

There wasn't a single soul in sight. In any other instance, this would be highly peculiar, but being that we were in the middle of a pandemic, the Park was expected to be eerily empty—what I didn't expect is the way it made me feel; a mix of awe, uneasiness, and understanding.

An empty row of benches was particularly inviting, so I took a seat and gazed out at the rolling hills of Central park; once littered with people, now completely empty. The grass was vibrant, glittering peacefully as the sun light caught the morning dew. There were no people to disturb the brilliance of nature or to litter the grass with their belongings. No one to break the silent stillness with endless streams of conversation. It was now the absolute presence of nature, and only nature, existing unbothered in the center of the concrete maze.

I realized that the essence of Central Park never really consisted of nature. *It consisted of people*—sitting in the grass, playing music, riding bikes, dancing, laughing, and playing. Something was always happening. Something was always getting in the way of nature. Why?

Central Park was a place of human presence.

However, the pandemic had given the park a chance to assume its rightful position as a place of nature encased in the man-made tomb of Manhattan. I sat on the bench under the tree and thought back to what Central Park once was—a grassy stage for the grand show of humanity.

I am like a blade of grass
One among many

A thousand lives they pass me by

All of them—my company

Unknowingly

A library of life laid before me

An infinite collection of beings
The human condition has captured my interest
Walking stories with varying themes

And I
Who identify
As the passerby
In every intricate plot.
As the stillness that watches the brilliance
Devouring moments, I recycle as art.

Watching this menagerie before me
The constant scene of spontaneous action
It keeps me content in my solitude
Life's most fascinating distraction

There is truly no better show on earth
Than human interaction.

After reciting the old poem in my head, *it hit me.*

Amid all the silent madness and concrete walls of the city, I had forgotten about nature. I had failed to recognize that inspiration was always around me. It was in the cracks and crevices of the sidewalk and the hidden parks that rest peacefully between the building alleyways. It was in the trees that lined the empty streets and the bushels of flowers that hung in the windows of apartment buildings.

I hadn't lost it at all, I had just stopped seeing it.

Even though there were no people around me to spark any inspiration, the world was still buzzing with activity. The birds flocked to the grass, the bugs danced around in the air, and the breeze gently rustled the leaves of the great Elm trees before me. At a molecular level, protons and electrons were chaotically bouncing around. The process of photosynthesis was occurring inside each and every plant. And somewhere in the City, there were the people that once filled the Park—sitting in their homes, living, breathing, existing.

I smiled at all the times I bumped into strangers sitting in this spot under a tree on a rock. I thought about all the people I met along the way while writing *Out Of Chaos*. I watched the birds. I imagined groups of people smiling, laughing, and eating.

I remembered **what was** and I sat with **what is**.

Then, I was inspired.

It's a good thing to remember: sometimes when things feel lost, when you feel lost—neither are really lost at all. Whatever you think has gone missing, is usually with you all long (and if it's not, it's probably in the spot where you left it last).

We're at the top of my stairs in front of the door to the roof...again.

Ups and Downs

I live on the 5th floor of a walk-up. There is no elevator. It's five sets of stairs straight to the top and one more if we're going on the roof. Sometimes I sat at the top of the stairs and did nothing. Sometimes I wrote. Sometimes I sat at the bottom of the stairs and gazed out at the lifeless street. I would study the big light fixture in the center of the foyer and analyze the mailboxes— covered in old, worn labels. I would ponder all the people that came and went, everyone who once called this place home, wondering who they were and where they may have ended up.

During quarantine, I sat at the top and at the bottom of my staircase more times than I can count and I thought about *everything.*

I thought about a lot about life.
Life is duality. Reality. Mentality.
It's people coming and going.
It's lessons, laughter, and sadness.
It's birds, trees, and busy streets.
Life is an ever-unfolding rose—an unknown story that's
constantly being written with every passing minute.

It's beautiful, it's crazy, it's hard.
Peaks and valleys.
Highs and lows.

Life is ups and downs.

Life is like...

The Walk-up

Life is like a five floor walk-up
Every day
I climb
Some days it feels like a mountain
And others
A steady incline

I've spent some time at the bottom
Dreading the tread to the top
Every step feels endless
Weak knees and out of breath

Halfway up
My tired legs
Scream to stay in place
Bursting lungs
Say "Just give up"
But my front door
Awaits

Slowly stepping
I continue
Stop to grip the railing
There's no use in giving up

With just one flight remaining

Inhale, exhale
Step, stop
Foot hits final floor
A mighty feat from bottom to top
And now, I'm at my door

Home feels like a victory
And so, I spend some time
But soon, I'll have to leave this room
To begin my slow decline

Other days are effortless
Energized and quick
A skip, a hop, I'm at the top
Without much time to think

Racing down
In leaps and bounds
And bursting out the door
That descent was troubleless

But next time? I'm unsure

Good and bad, easy and hard
Is divided up in shares
Every day is up and down

A different

 set

 of

 stairs.

Sleepless Prowl

On hollow branch of ebony oak
Against the chilling breeze
Perched above, observing
The scene below the trees

Hiding in the twilight
Beneath the evergreen roof
My talons cling to timber
As I seek the night for truth

Peering through the midnight window
Widened eyes
Alert
The crack of bark
I grip the bough
Above the earth, I search

Dampened leaves
And scattered twigs
Coat the eerie trails
The blackened road less traveled
I hunt what it entails

I, the wise and feathered
The guard of starlit hour
A predator
Doomed to stalk the night
My curse of sleepless prowl

While you sleep

I roam the sky
My quest is absolute
Gliding in the moonlight
As I search the grounds, aloof

My eyes are still and piercing
I swoop
And swallow whole
All knowing, I the owl

As above it so below.

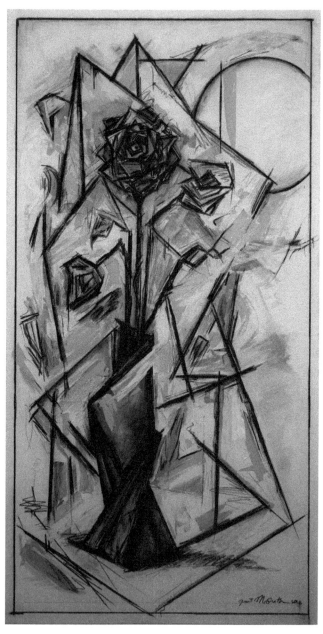

"In Bloom"Acrylic, charcoal on canvas, 32 x 60 in., 2018. Artist: Grant McGrath.

Rainfall and Roses

In an effort to forget the madness of life
I turn my attention to love
I imagine…
A bouquet of a dozen roses
The flight of an elegant dove

A spot at the park in the crook of a tree
Birds chirp and flowers bloom
Golden sun hits wisps of grass
The wind sings Nature's sweet tune

Sleeplessly dismissing my sadness
I imagine life's beauty forgotten
Like the dewy haze of summer sun
And the crimson leaves of Autumn

How lovely
Be the smell of rain?
The dried lavender on my wall
Closing my eyes
I imagine

And fast asleep, I fall.

Nice to Meet You, I'm Reality

Wash that henna off your hands
Take the purple out of your hair
It's supposed to be brown

Tame those curls, girl
Straighten up, straighten out
Get your head out of the clouds

You're delusional
Take the glitter off your eyes
Fall in line
Forget about words that rhyme
I SAID FORGET ABOUT WORDS THAT RHYME
No, pennies aren't lucky
No, sentences aren't special
No, there is no *magic* in your *madness*
It's just madness
And while you're at it, get this:
You made it all up in your head
So
Put the pen down
Walk away
Don't look back
You're foolish for standing out
In a world where you're supposed to fit in.

Accompanying painting on pg. 186, "Self Portrait 05: Hold it Together," Acrylic, charcoal on canvas, 24 x 30 in., 2019

Hello Reality, I'm Natalie

I refuse to grasp those truths
Attacking my mentality
I won the battle of my mind
So, I'll win this battle with reality

My head is fine up in the sky
Gladly prancing with illusions
A sparkle in my iris
My hands full of conclusions

I SAID FORGET ABOUT WORDS THAT RHYME
So sorry but heads up
I just haven't got the time
Because *madness* without *magic*
Is where I draw the line

It's my imagination that's enchanted
Yes, it's made it up in my head
Truly it's just artistry
My magic wand—a pen

Beautifully chaotic, chronically insane
I'd rather be wildly different in world where all is the same.

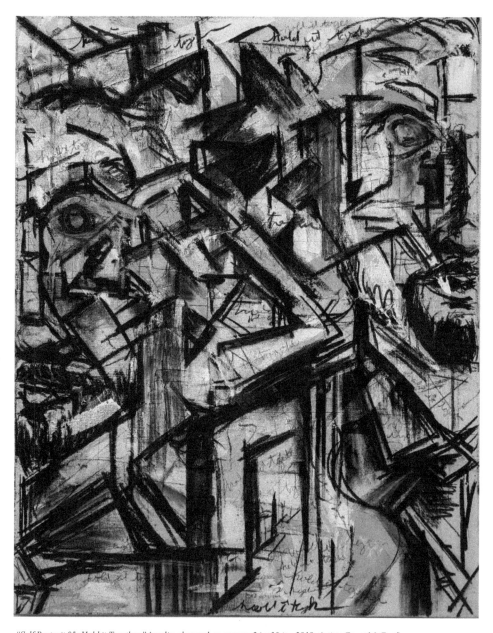

"Self Portrait 05: Hold it Together," Acrylic, charcoal on canvas, 24 x 30 in., 2019. Artist: Grant McGrath.

FORGET ABOUT WORDS THAT RHYME FORGET ABOUT WORDS
FORGET ABOUT WORDS THAT RHYME FORGET ABOUT WORDS
FORGET ABOUT WORDS THAT RHYME FORGET ABOUT WORDS
FORGET ABOUT WORDS THAT RHYME FORGET ABOUT WORDS
FORGET ABOUT WORDS THAT RHYME FORGET ABOUT WORDS
FORGET ABOUT WORDS THAT RHYME FORGET ABOUT WORDS
FORGET ABOUT WORDS THAT RHYME FORGET ABOUT WORDS
FORGET ABOUT WORDS THAT RHYME FORGET ABOUT WORDS
FORGET ABOUT WORDS THAT RHYME FORGET ABOUT WORDS
FORGET ABOUT WORDS THAT RHYME FORGET ABOUT WORDS
FORGET ABOUT WORDS THAT RHYME FORGET ABOUT WORDS
FORGET ABOUT WORDS THAT RHYME FORGET ABOUT WORDS
FORGET ABOUT WORDS THAT RHYME FORGET ABOUT WORDS
FORGET ABOUT WORDS THAT RHYME FORGET ABOUT WORDS
FORGET ABOUT WORDS THAT RHYME FORGET ABOUT WORDS
FORGET ABOUT WORDS THAT RHYME FORGET ABOUT WORDS
FORGET ABOUT WORDS THAT RHYME FORGET ABOUT WORDS
FORGET ABOUT WORDS THAT RHYME FORGET ABOUT WORDS
FORGET ABOUT WORDS THAT RHYME FORGET ABOUT WORDS
FORGET ABOUT WORDS THAT RHYME FORGET ABOUT WORDS
FORGET ABOUT WORDS THAT RHYME FORGET ABOUT WORDS
FORGET ABOUT WORDS THAT RHYME FORGET ABOUT WORDS
FORGET ABOUT WORDS THAT RHYME FORGET ABOUT WORDS
FORGET ABOUT WORDS THAT RHYME FORGET ABOUT WORDS
FORGET ABOUT WORDS THAT RHYME FORGET ABOUT WORDS
FORGET ABOUT WORDS THAT RHYME FORGET ABOUT WORDS
FORGET ABOUT WORDS THAT RHYME FORGET ABOUT WORDS
FORGET ABOUT WORDS THAT RHYME FORGET ABOUT WORDS
FORGET ABOUT WORDS THAT RHYME FORGET ABOUT WORDS
FORGET ABOUT WORDS THAT RHYME FORGET ABOUT WORDS

Roof Top Thoughts

I learned a lot being locked on a rooftop
Staring out at the buildings each night
In every window, a story of someone
Every light representing a life

Hundreds of people
Surround me
Silhouettes behind the glass
The moonlight hits the building bricks

And I'm lost in the shadow it casts.

The slightest breeze hits my cheeks
The city buzz becomes a hush
This silence is soothing
Along with the wind
That seems to sing as it
Carries my thoughts

I sit and imagine the people
Their identities forever unknown
At least, it seems much less lonely

In the presence of thousands of souls.

Missing Sunrise

Henna fades
Seasons change
Night always runs from day
The weather never settles
Birds land

Then, fly away

I watch them as they sway
Dancing in the winds
Following the rolling clouds
As another day begins

Thoughts come and go, like people
The moon and sun part ways

I sigh into the morning glow

"Nothing ever seems to stay"

The butterfly's go floating by
The flowers bloom then wilt
The snowfall paints a world of white
Just before it melts

A shooting star
A fire spark
A conversation
Lasting minutes
I turn my back
The moment's passed

And now, I'm back to missing

Hidden in these similes:

"I can't bear to see you leave"

But, like the autumn landscape

Life changes with the trees.

The Green Grass

Surrender your worry
You are worthy
Your soul will veraciously beam
The world opens up and abundance erupts

When you learn to let go and let be

Discontent reigns supreme
When you choose to not see
To be restless
Dismissing your blessings

Yes, the journey ahead is winding
Full of hardship, sadness, and lessons

Under a guise built by millions of eyes
Feeling trapped, unfulfilled, and afraid

Fighting a need
To escape and be freed
From the miserable bed
That's been laid

But have faith
There is always a sunrise
And have hope
That this too shall pass
For on one side
Thorns and fire
But on the other...

The greenest of grass.

At last.

All Forms of Flight

I am the freest of birds
In every form, I fly
As the peace of a dove
With the mind of a crow
Against the sky, I glide

The wisdom of the owl
The eyes of the hawk
I seek, therefore, I know
From the clouds
I peer down

As above is so below

My wings span over the ocean
Against the wind and sea
Carried by air, guided by sun

Like the eagle
Majestic and free

 pigeons
 the
 with
 flight
My words take
A song that rings
Through the trees
From my nest
Against the birch

T h e n c a r r i e d a w a y b y t h e b r e e z e

The swan, both pure and lovely
My innocence ripples the lake
A duckling, lucky and lonely
And a seagull, searching the waves

The vibrancy of a canary
Yet stoic like the crane
Quick, I dart like the sparrows

And like the Phoenix,

I rise from the flames.

It doesn't matter where we are.

It's a Beautiful Day

The sun is shining.
The birds are chirping.
The sky is a brilliant shade of blue.
The sun is beating down on my shoulders and a slight breeze is rustling my hair.
I'm on a bench, finishing the last poem for this book.
There is the faint sound of passing taxis and chatting people floating around me.
The city feels as if it's coming back to life.
People are little bit happier.
I am happier.
Balanced.
Whole.
Both sides of myself at once.

I am **here**

I am **now.**

Finally...

The Beautiful Battle Ends

At war with the beasts inside my mind
I've battled them time and again
So much so
I've come to know
Each monster as a friend

Their swords are words
They slash and slay
It seems there's no end to this madness
A mind of confusion in ruins
The battleground
Ashes and sadness

I battle the world's spontaneity
Unexpected
Unwelcome
Reality
Upon entrance
It beckons
Mass destruction
To win, I must balance mentality

The "What happens next?"
Seems to feed my unrest
So, I surrender to whatever the outcome
Good or bad
I wave the white flag
And let reality choose between which one

An ocean of explosions
And colorful bursts
A rainbow of fire ignites
This beautiful battle
Comes to an end
Once I let good and bad coexist

The olive branch has softly fallen
As unity ends this plight
The missing piece:

All darkness

Must balance the presence of light.

I started writing *The Aftermath of Unrest* the moment *Out of Chaos* went into layout. I knew the story would unfold before me but I had no idea it would turn out the way it did. So much has happened between then and now. All of it was totally unexpected, most of it was extremely difficult, and some of it was really great. The beauty of life is that no matter what happens, *we learn from everything we experience.* Good or bad. Easy or difficult. Everything becomes a lesson.

We level up.

I knew the pandemic was going to test my mental limits, as I would be forced to sit in isolation with one thing: *myself.* This meant there would be a war with my thoughts during the entire quarantine experience. I clung to one thing: Accept what is happening because the only way out is through. The idea of accepting reality, mentality, and the duality of everything led me to two questions: How does one achieve acceptance? And what is it?

Acceptance is the place somewhere between the hopeful unknown and the harsh truth of reality.

In terms of what was happening in the world, the hopeful unknown was: "This will only last a week!" "Everything is going to be just fine!" "You can make it through anything!" The harsh truth of reality: "This is going to get worse before it gets better." "You're going to have a lot of time with your mind!" And, my personal (over dramatic) favorite, "The world is ending!" In terms of my mind, this juxtaposition boiled down to one side shouting "You are strong!" and the other "You are weak!"

There has always been a battle with the positive and negative sides of my mind. For every good part of me, there is an equal or lesser bad part of me. Newton's third law again: *for every action, there is an equal or opposite reaction.* The same can apply to characteristics of the personality. For every good thing about me or you, there are a multitude of blessings that accompany them. For every bad part there is an endless stream of consequence. In my case, a consequence of my madness is being restless and anxious. Yes, the mind is a battlefield of both good and bad but the goal is to turn that battle of the mind into a balancing act.

Reality was hitting hard and I no longer wanted to be a victim of my mind's inequality. I wanted to be neutral. It was time to wave the white flag and become an ally. I needed to accept the reality that I will always be split into the sides of myself. When I realized that, something happened. *Balance.* I felt at peace with the madness in my mind, therefore, I could face the madness of reality. I could not be defeated with my mind on my side. There was no longer mental inequality. Everything became congruent.

Dear Reader, mentality and reality must work together, not against each other. When you find that balance, *duality becomes unity.*

But, how exactly does one find balance? It seemed like I had all the time in the world to figure it out now that time itself seemed to have stopped. The world was frozen in time. It was almost as if life had become like an abstract painting. It could be this or it could be that. *It was whatever you wanted it to be.* Without time, everything was still. Ha, stuck without time...*what a concept.* Free to be. There was no being confined to days, hours, and minutes. It all became one incredibly endless blur.

A life without time is quite freeing if you choose to see it that way.

Some of us were faced with an out—an escape from the repetitive loop of everyday normalcy. Life as we knew it changed drastically in an instant. Everything paused. This glitch in the matrix had a purpose. It slowed us down and pushed us to *recollect and reconnect.* Please note, this perspective **is not for everyone**. Quarantine and COVID-19 was tragic and many of us were affected in horrific ways. But, for those of us fortunate enough to experience this time as a 'pause' well, I can only hope you were able to see the beauty of this timeless reality.

Alas, humans are defiant by nature. We are conditioned to "do" and when we're told to be still, it feels like chains. It was hard for many of us to see past the imprisonment of 'shelter in place' orders. It was hard for many of us to adapt. In general, it is hard for humans to find balance in the chaos of life itself.

It's interesting—when we're tied to normalcy, *we complain.* When we're free, we crave structure. Humans are such flawed, unsatisfied creatures.

We are materialistic beings that rely on our innate ability to constantly interact; go places, see people, do things, and buy items we don't need. We're conditioned to work. Endlessly work. And worry. Endlessly worry. However, when something like this happens, reality urges us to drop the veil of our ego. In turn, we are forced to take a long hard look at what truly matters—take a moment to reflect and enjoy the stillness. When we do this, the chaos of the world settles and it becomes magnificently peaceful. We are able to recognize the timeless world at our fingertips, one that can allow for us to go back to our roots and reevaluate our choices. This timeless reality was an opportunity to help us all re-balance. It was a new world and a new way of living, one we didn't ask for but *desperately needed.*

Remember, there is no light without dark. There is no good without evil. Yes, these were dark times; full of sadness, loneliness, sickness, fear, stress, and uncertainty. During those first few months of the pandemic, we were faced with every form of evil. Our task was to shine through this harrowing reality and somehow rise from the ashes as stronger, better, and more understanding. Our task was to appreciate. Accept. Find strength in the madness of the world and help each other. To remain strong, learn, and *never give up*—even when the world felt like it was ending.

So, through all this chaos of reality and mentality, I allowed myself to get lost in time. I dropped the clock and shred the calendar. I sat with duality and reality; letting them meet, mix, melt, bend and throw me, yet again, into an ocean of chaos. **Then, I waited.** Finally, I began to accept them as equal halves. The give and take of good and bad. I started recognizing the delicate balance of duality and reality. They began to co-exist. *They unified.*

I discovered balance in midst of chaos and chaos in the midst of balance.

I found acceptance at the root of everything.

Dear Reader,

Once you accept everything for **what it is**
there is no other choice but to exist at peace.

There is no other choice but balance.

The Most Extraordinary Story

THE ROSE PARK

Alright Reader, so far, we've covered how **architects** and **artists** have a played a role throughout my poetic journey and hopefully, you're following along. Before I can blow your mind, we're going to introduce one more location and one more connection point.

Roses.

The rose has played a significant role in my poetic quest. Let's start with the evening that inspired the poem *The World of Fake Roses* from *Out Of Chaos*. The Artist and I were wandering the streets and stumbled upon a hidden **rose** park behind the TJ Maxx on 59th street. It was a magical place.

The bushes that outlined the park were blossoming with **roses**. Strings of dazzling lights were woven around the bushes and in between the dark, green leaves that were entangled in the lattice. At the center of the garden stands a magnificent fountain statue. The surrounding lights twinkled in sync with the water that was slowly trickling from the head of an ox at the base of the statue. The granite sculpture resembles a headstone and serves as the frame for a mosaic portrait of a woman. She's elegant, colorful and sits gracefully, surrounded by an abundant cornucopia.

I tiptoed up and leaned over to smell one of the roses. To my surprise, there was no scent. I reached out to touch the flower and rubbed the petal. My fingertips were greeted with coarse, worn fabric. The roses were fake. Disappointed, I took a step back—half admiring the beauty of the park, half annoyed by its unexpected deception. I walked back over to the lattice at the entrance of the park and stared at another bushel of flowers. There was stem that was tangled in the framework, wrapping down and around into the flower box. At the center of that stem was a single rose and it was real!

What a delightful discovery, to find a real rose in a sea of fake flowers. They were all equally beautiful; but they were not real. This was an important lesson of life: Looks can be deceiving.

RETURNING TO THE ROSE PARK

The rose park is a beautiful, quiet place to write, but I hadn't been there since that night. During the final stages of writing *Out of Chaos*, I wanted to visit all of the places where I had been inspired. Of course, I ended up at the rose park. When I got there, all the roses were gone. How could fake roses disappear? The bushes were there. The lights were there. The roses were nowhere to be found. It was as if they'd never even existed in the first place. Distraught, I searched the bushes. Nothing. No evidence. The roses were gone, officially nothing more than a memory, a moment in time, and a poem in my book. Was it real? Was the memory, in fact, as fake as the roses?

I sat down in front of the fountain completely baffled. Overwhelmed, I stared at the mosaic woman. Her glass eyes stared back and her everlasting smirk felt taunting.

"What're you looking at?" I sneered and picked at the grass. "Who even are you?" Curiousness is always the greatest distraction and the wandering thought intercepted my swirling mental madness. I gazed at the statue and decided I didn't care to know.

Out of nowhere, all of my poems came crashing to the surface of my mind like mental poetic avalanche. They were all there, front and center, in my head. They all wanted out. I grabbed my notebook and immediately started writing *The Symphony of Symbolism*. This is important to remember for later in the story: *The Symphony of Symbolism* is the poem where all of my poems come together in one long piece.

Time passed. A week before the official release of *Out of Chaos*, during a morning stroll, I came across a single frozen rose. It was laying on the top of a trashcan in front of the park down the street from my apartment. I picked it up and took a picture of it in front of the rising run. It reminded me of *The World of Fake Roses*. I smiled and thought back to all the moments that led me to where I was. This beautiful rose had not only stopped me in my tracks but it allowed me to appreciate the bigger picture. It felt like a sign that I was on the right path.

It felt like another connection point.

Time passes.

It moves forward and back.

Out of Chaos is in the world.

Reality happens. Covid-19, quarantine, and civil unrest is happening.

The city falls silent.

I keep writing.

Time stops...

I SAT DOWN TO WRITE "WHICH SIDE"

"I stared at the heavens, I cried to the skies

I begged for a definite path, I prayed for a clear direction..."

The Aftermath of Unrest was coming together really fast. I had no control and no idea how the story was going to unfold. I knew the time had come to think about cover art and illustrations. There were a few artists I had in mind but I was too confused on what to do next. I felt stuck, anxious, and uncertain. Ah, here we go again...book anxiety. To my *Out of Chaos* reader, we all know what happened last time book anxiety showed up: *Grammatical Massacre.*

I begged for a sign of what to do next.

Well, dear Reader, *ask and you shall receive.* Believe me when I tell you that someone must've been listening that night on my roof. Whether it was God, the Universe, the Angels, the saints, the Ethos, the world or Spirit; something answered my prayers. It's the only thing that can possibly explain what happened next.

Summer was approaching and warm weather always seems to bring about a little more happiness. As June rolled around, so did the re-opening of New York City. This meant more places to go, things to do, and people to see. The more the world opened up, the more signs I started to notice.

Yes, I said it. *Signs.*

It started with **roses**. There were roses *everywhere*. I wasn't looking for them, they just kept popping up in peculiar places. They were on stranger's shirts and pants, and written on the windows I had just happened to be standing under. There were roses in the background of my photographs and popping up in parks where they hadn't been the day before. On one occasion, I walked by couch on the sidewalk and even that was covered in roses. They were in songs, conversations, and in a few of my old poems I stumbled on.

Roses everywhere.

Next, I mysteriously got ***The Hunchback of Notre Dame*** stuck in my head. I'm not sure if I heard it in a song, a conversation, or a video—but for some reason, it was all I could think about. I watched the movie. I listened to the soundtrack. I read articles about it. It was extremely unusual. *I couldn't get it out of my head.*

Then, a stack of **architecture** and **art** books popped up on a trashcan down the street from my apartment. At first, I thought, "YES! Architecture! I must be on the right path!" Then, a second thought crossed my mind: *The Artist.* One of the books reminded me of his beautiful sketches of New York City. On that very same day, I ended up on Park Avenue. There was a man sitting at the fountain reading a book. Guess what book he was reading? *The same book I had given to the Artist*—same time, last year.

I looked around at the buildings confused about everything that was happening. I needed to clear my mind. Google is great in moments like these, it's a master of distraction. I started thinking about how it had never occurred to me to research the name of the building with the fountains. After a quick search, I discovered that it was called The Seagram Building, and it is an **architectural** treasure trove. This led me to spend the afternoon researching the **architecture** of Park Avenue. I know what you're thinking, "How is that another sign? YOU took it upon YOURSELF to research architecture." Maybe, but the timing was impeccable.

The distraction didn't last for long and I still didn't understand all the

weird things that were happening around me. I sat at the fountain thinking about my book and what to do next. If **architecture** means "I'm on the right path," could the roses mean something different? Then it hit me. The world itself was shouting "Roses!" I remembered *The World of Fake Roses* from *Out of Chaos* and the Artist. There was only one place it could lead.

I walked to the **rose park.**

When I arrived, there was a strange woman sitting adjacent to the fountain. She immediately glanced up and shot me an angry stare. Hostility was practically dripping from her skin and it was unsettling. My body immediately rejected her presence and I gravitated as close to the fountain as possible to create distance. The edge of the statue at the base of the fountain is covered by a large bush. Since I had gotten so close, my arm moved the branches out of the way revealing a side of the statue I'd never been able to see. Engraved in the stone, hidden behind the thick of the rose leaves, was a name: **Evangeline Wilbour Blashfield.**

I thought, "Huh, *that's* who she is?" It was odd that I'd never seen that before. I came to the rose park all the time. I stared at the fountain *every time*. How was I just seeing this? Well...

Fate has an funny way of showing you exactly what you need to see, exactly when you need to see it.

Alright Reader, take a deep breath. Get ready for the ultimate connection point.

EVANGELINE WILBOUR BLASHFEILD

Immediately, I pulled out my phone and searched her name. What happened next is nothing short of unbelievable.

Ready? *Are you sure*? OK.

Evangeline Wilbour Blashfeild was a famous **author**, intellectual, and woman's rights activist from the 1800's. She was originally born in **Rhode Island**. Her husband, whom she met at **dance**, was the famous **painter**, Edwin Blashfeild.

By now, you're probably rolling your eyes, "Ok, Natalie. That's a coincidence." There's more.

Evangeline and her husband are most notably known for the book they wrote together, called *Italian Cities*. This book focuses on two things: **art and architecture**. See, Edwin and Evangeline were very close with many architects and artists in New York City and Italy. They were passionate about the history and relationship of the two and wrote many books together focusing on the topics.

In every joint project, *Evangeline had the words and Edwin had the pictures.*

Still, coincidence? Yeah, *maybe.* Except, there's more.

Edwin painted a beautiful portrait of Evangeline. She's sitting on Victorian couch and wearing a yellow dress...covered in **roses.**

I know, I know. It still could be the world's most perfect coincidence. I thought the same thing, except...

Evangeline's father was known for translating screen plays. His two most notable works include: Les Misérables and...

The Hunchback of Notre Dame.

FATED CONNECTIONS

Take a moment to let that all the set in. Did you have a "Whaaaaaaat nooo wayyyyyy" moment too? As soon as I finished reading Evangeline's biography I knew I was *exactly where I needed to be*. There was not a doubt in my mind that I was following my life path in the right direction. All the signs came together in one place. The same place where all my poems came together while I was writing *The Symphony of Symbolism*. Symbols. Connection points. Signs. It was the holy grail moment. The world's biggest connection point. All the pieces of the puzzle fit perfectly into place. I was dumbfounded. Then, the reality of the situation came crashing down. Was I getting signs this whole time from a ghost? From a spirit? From the actual Universe? Connection points are beautiful reminders that we're perfectly aligned on our life path and that everything is happening as it should. However, everything up until Evangeline were real connection points. This felt much bigger.

There are forces in the world that we simply cannot understand and this discovery extended far beyond coincidence. Whether it was divine guidance or spiritually led, the universe itself was trying to tell me something. *What else could it mean?* After the shock settled, I took a step back and very deep breath. There was an underlying theme and it was screaming at me.

Evangeline partnered up with artists.

I already knew I wanted to illustrate this book and I knew it was time to think about cover art. After putting all the pieces together, I came to another conclusion: All the signs point to working with an artist. The Artist from *Out of Chaos*. Oh, boy. My mind went wild.

In *Out of Chaos*, I wrote that crossing paths with him again was up to fate to decide. Was this fate's decision? Was this fate's way of pushing me back in the direction of working with him? I had no way of knowing. We hadn't really spoken much and it felt like life had moved on for the both of us. It also didn't help that we were smack dab in the middle of a pandemic. There was another problem, too. I sounded absolutely crazy! It's not exactly normal to approach someone and tell them, "Hey! I've been getting signs from the universe about my life path and some them

point to you. Oh, and by the way, a ghost lady might've been involved. Basically, I think we're fated to work together!"

At this point, I was completely perplexed. Baffled. Mind blown. You name it, I felt it. I started seeking opinions from people that I trusted. I felt crazy, like a madwoman who had made it all up in my head. How could you not? But, I wasn't. Everyone was telling me the same thing:

"No, you're not crazy."

"Yes, you're on the right path."

"Yes, all signs point to the Artist."

I sat with this remarkable discovery for a few days. After letting it all sink in, I knew what I needed to do. The answer was there all along, right under my nose, and down the street at the rose park. Fate had finally found a way to make me see it. This was all real and I had to follow the direction in which I was being led. Besides, it is never a wise decision to fight fate.

Now, we're back to our good old friend, fate. Yes, **fate is real**. It is clever and cunning. It is unexpected. It will always find a way to bring you back to where you're supposed to be. Fate is smarter than reality, it works around it, bends the rules of the universe, and always figures out a way to re-direct our course. That's how you know fate is involved. *It will leave you absolutely shaken.*

Boy, was I shook.

There is an endless list of cheesy motivational quotes splattered across the internet. Guess what? They're all true. If it's meant to be, it will be. Everything happens for a reason. The universe conspires to make it happen. Every action has a reaction. God talks back. Anything is possible. Dream big. Don't give up. Shoot for the moon. What goes around comes around. Question everything. Believe. Never lose hope. Trust the process. Follow your heart. Trust your gut. Follow life in the direction it leads. And, my personal favorite: *You can't fight fate.*

You can roll your eyes. Call me crazy. Call me cliché. Shake your head and say that "Nothing happens for a reason." or "That was all coincidence," or "You got it all wrong girl!" Or, you can smile, have hope, and believe that it's all real.

I *believed*. There was no denying any of this.

The universe was telling me one thing but my mind and reality were telling me another. There was a harsh truth that I knew I had to face: The Artist could say no, he might not answer at all, or he could think I'm crazy. He could be busy with another project or dealing with something else. Not to mention, *we were in the middle of a global pandemic*. There was a long list of many things that could get in the way of all of this. *Such is life*. People come and go but life never stops. Although we had made a unique connection—life goes on. People change. Above all, you can't expect someone to drop everything and welcome you back into their life. I had no idea where he was or what he was doing. However, after looking at the situation from every angle.

I decided it didn't matter.

Alas, my intuition won the war with reality. It was clear as day what I needed to do. Even if it didn't work out, I had to follow the signs in the direction in which I believed they led. It was time to get in touch with the Artist and talk to him about all of this—regardless of the outcome. At least, *I had to try*.

This was the ultimate test of trust. Trusting my new-found intuition, the Universe, and myself. For the first time, it all came down to following my heart and not my head. This entire endeavor would require the greatest leap of faith. It would require an open mind, heart, and soul. And, the complete demolition of what reality says is "possible." After all, we're talking about a higher work at play here.

Here's the thing: sometimes, you have to let yourself see past reality. Be open to the unknown. You have to let the walls come crashing down between the realms of "possible" and "impossible."

You have to believe even it's unbelievable.

So, I loaded up my metaphorical car with every absurdity, hopped in the passenger seat, and let fate take the wheel. The destination? Totally unknown. My mind? Ever chaotic. My gut? It knew exactly what it was doing.

I reached for my phone and texted the Artist.

"Hey. Hope you're well! I would like to discuss a potential opportunity. This is all going to require a leap of faith and very open mind...see, we're the main characters in the most extraordinary story..."

Forever in time

However it bends

The most extraordinary story

Begins where it ends:

The Artist and the Poet cross paths again...

TWO PEOPLE

Time is funny—so much can happen as it passes yet it can feel like it hasn't passed at all. Exactly one year had passed since the Artist and I had first crossed paths. I never could've imagined everything that happened as a result of our random chance encounter.

Remember: You can never be sure how someone will impact your life.

It's a beautiful thing, the ripple effect of a simple hello.

It can change everything.

He answered and agreed to hear me out. We met at a park and sat on a fence under the blazing morning sun. He listened intently as I told the entire story from start to finish.

The story of architecture, roses, and coffee shops; random chance encounters, connection points, and guidance from the universe. The tale of moments, poems, and passing time. All the signs that led to here and now. The most extraordinary story of poetry, art, and fate. One that all began with a poem and a painting. One that all began with:

Two people...

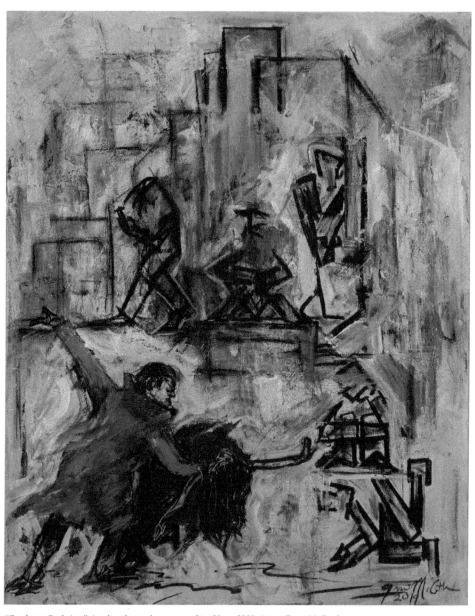

"Sonder on Park Ave," Acrylic, charcoal on canvas, 24 x 30 in., 2019. Artist: Grant McGrath.

The Inverted City

Two people

The upside down city their playground
A world that dazzles beneath their feet
Wandering souls
Two minds, stuck in time
Drifting aimless
Unexpected

They meet

Enthralled with the chaos of streetlights
A mess of buildings crafted from glass
They shatter the world with their presence
And watch as the structures collapse

Concrete crumbles to the ground around them
A peaceful whirlwind of dust and debris
The Inverted City of silence
Of stillness, calmness, and ease

The city flips
And it spins
And with it, they danced
Entranced by outlines left behind
Surrounded by **sonder** on Park
Enchanted
Two souls

Now entwined.

THE LAST OF THE ROSES

The most interesting twist in this extraordinary story is what we discovered as we started working together. At first, we thought the artwork would be sketches and illustrations; but after reading the entire book, he expressed how most of his paintings *already matched my poems*. It was as if our brains were two separate radios tuned to the same creative frequency. The mind-blowing discovery? My poems have always matched his paintings—*even before we met*. It was as if this collaboration was always meant to be. Not only that, but since I had followed the signs to the Artist, everything felt like it was falling into place. I assumed the roses would stop showing up. They didn't. In fact, they started showing up *even more* than ever before, especially in the weeks leading up to when we were to paint the cover.

St. Patrick's Cathedral is one of my favorite places. It is dripping with spectacular architecture. I like to go there and sit in silence, to clear my head and marvel at the strained class windows and intricate marble arches. And of course, to pray. This entire journey had me quite frazzled and I found myself sitting in the pew one day completely distraught. I stared out at the golden detail carved into the ceiling. Then, I hung my head and whispered, "Please just give me one more sign!" When I glanced up a man was walking down the aisle. His shirt had a rose on the back and his shorts were completely covered in roses.

After leaving St. Patrick's, I bumped into a man standing on the corner waiting to cross the street. I stumbled back and noticed a huge rose tattooed on his arm. The words came spilling out of my mouth in lightening speed, "IknowthisisgoingtosoundcrazybutIamwritingabookandroseshavebeenmysignandIjustbumpintoyouandyouhaveaGIANTROSEtattoo?!?!"

He blinked at me in disbelief. Then, he laughed and said, "You know, my aunt wrote a book too. It's all about **roses**."

"Really?" I gasped.

"Yeah." He smiled, "It's about how **roses** were her signs."

I almost passed out on the sidewalk. *What are the chances of that?*

A few days later, my friend invited me to her apartment for the first time. When I walked in, I almost fainted. **Her apartment was covered in roses**. They were everywhere. She had rose pillows, roses on the table, and bright, red rose-covered curtains. On almost every table there were vases full of freshly cut flowers. And, in the back of her apartment—a flourishing rose garden. I turned as white as ghost and blurted out, "What the hell is up with all these roses!?" Confused by my reaction, she laughed nervously, "Oh yeah, I love them." As if the universe hadn't blown my mind enough, I had finally hit the rose mother load. I had officially entered the mother-ship.

Why was I still seeing roses and at such an alarming rate?

Well, it could mean only one of two things:

1. I was on the right path. The project was gaining momentum, therefore, so were the roses. They were a reminder to hold my vision and not to give up.

2. I was wrong and the roses meant something different.

I chose option one. Why? Because I decided to trust my gut. I made the choice to *believe* that I was following the signs in the right direction. I decided to continue to believe despite the possibility that I could be totally wrong.

Up until *The Aftermath of Unrest*, my whole life had been seeded in the need for validation. I've always craved it and sought it out in the words of others. It seemed like every time I put my faith into something or someone, I ended up wrong. Even though I was being bombarded with undeniable signs, I was living in perpetual uncertainty. I had to learn to believe in myself and my intuition, even if it meant being wrong. It was time to drop the need for validation.

Finally, the day came to meet with the Artist and paint the book cover. As I was walking up to his Brooklyn studio, the song "Roses" started playing on my Spotify shuffle. I chuckled, rolled my eyes, and kept walking.

Alright universe, I get it.

The process of painting my portrait was an incredible experience. He chose to paint a live portrait of me using his own unique method. This involved setting up a mirror and painting my reflection. The set-up allowed for me to watch him paint in real-time, instead of being behind the canvas. I was able to watch my portrait come to life as he carefully added strokes of paint to the picture.

The room was entirely silent and I sat there completely mesmerized. The energy surrounding us was an absolute intense stillness. He asked me to keep my gaze fixed and my position as still as possible. I'm not the greatest at staying still or silent so I let my mind wander around the room. I examined his movement as he painted, analyzed the concentration splashed across his face, and focused on every move he made. Every few minutes, my eyes would dash over to the canvas and another feature would appear.

I came to life as a painting before my very eyes.

At one point, my gaze drifted over to the back of his arm as he reached up to add another stoke of paint to my cheekbones. His sleeve slightly lifted to reveal a tattoo. *A tattoo of a rose.* It took every fiber of my being not to shout, "YOU HAVE A ROSE ON YOUR ARM!?" The last thing I wanted to do was break his concentration. Instead, I smiled. Once and for all, I knew that I had followed the signs in the right direction. I was exactly where I needed to be. *I was right.* It all came down to trusting myself and what I believed in—despite how incredibly insane the entire journey had been.

He took a step back and we observed the finished portrait. It was a surreal moment and I was speechless. *The painting was beautiful. She was beautiful.* After struggling with the person in the mirror for so long, I never thought I would be facing her as a work of art. I looked in the mirror and then at the portrait. It was like seeing myself for the first time.

WHO IS SHE?

Lost in thought and completely transfixed—I sat on the paint-splattered floor and gazed up at the portrait. I stared into her eyes and traveled everywhere in time.

I thought back to the very first day I met the Artist. I remembered how our random conversation in the elevator became an impromptu walk through the city. I remembered the girl who was terrified to share her poetry and when she finally read her poems to a stranger on Park Avenue—the moment that changed *everything*. I remembered the days she couldn't get out of bed or face the world. The hours of therapy. The hours of over thinking, self doubt, and false perception of self. I remembered all the pain and all the words that came from it. I remembered every restless evening spent tossing and turning, crying, and praying for better days. I remembered looking into the mirror and seeing nothing but a reflection of a person I didn't know.

In her portrait, I saw the reflection of every tear-filled sunrise. Every attempt to silence the chaos by simply being thankful to see a new day. I saw every lonely night spent on her roof during quarantine. The empty city. The sirens. The chilling, terrifying fear of the unknown. I saw her sadness and uncertainty. Her happiness and passion. I saw fire. Drive. An undying curiousness.

I remembered every moment that led to here and now and I saw everything.

Every emotion. Every poem. Every obstacle. Every challenge. Every victory. And, in her eyes, I saw triumph. I saw *hope*.

I began to recite *Who Is She*, the opening poem from *Out Of Chaos*. Except this time around, I knew exactly who she was and who she is:

She is me and I am her.

"Natalie" Acrylic on Canvas, August 30, 2020. Artist: Grant McGrath.

Dear Reader,

I hope this extraordinary story helps you realize that if you believe, *anything is possible*. You can believe that *anything and everything can happen*. You can believe in all of those cheesy quotes about fate and faith. You can believe in signs, higher powers, and messages from the universe. You can believe that fate will always bring you back to where you're supposed to be and that if it's meant to be, it will be. If you trust yourself and follow your intuition, it will never lead you astray.

Believe in the unbelievable.

Most importantly, believe in yourself.

But...*why* should you believe?

Well, when you truly believe in the unbelievable, *everything is possible* and your life can be anything you want it to be.

Life can be an extraordinary story.

Wouldn't you like to be the main character?

Where are we in time?

Let's just...throw away time.

Let's forget about days, minutes, and hours.

Throw away our clocks and calendars

Let's measure in **moments**

Experiences

Laughter

Friends

Let's measure everything with life.

WHERE ARE WE IN TIME WHERE ARE WE IN TIME WHERE ARE
WE IN TIME WHERE ARE WE IN TIME WHERE ARE WE IN TIME
WHERE ARE WE IN TIME WHERE ARE WE IN TIME WHERE ARE
WE IN TIME WHERE ARE WE IN TIME WHERE ARE WE IN TIME
WHERE ARE WE IN TIME WHERE ARE WE IN TIME WHERE ARE
WE IN TIME WHERE ARE WE IN TIME WHERE ARE WE IN TIME
WHERE ARE WE IN TIME WHERE ARE WE IN TIME WHERE ARE
WE IN TIME WHERE ARE WE IN TIME WHERE ARE WE IN TIME
WHERE ARE WE IN TIME WHERE ARE WE IN TIME WHERE ARE
WE IN TIME WHERE ARE WE IN TIME WHERE ARE WE IN TIME
WHERE ARE WE IN TIME WHERE ARE WE IN TIME WHERE ARE
WE IN TIME WHERE ARE WE IN TIME WHERE ARE WE IN TIME
WHERE ARE WE IN TIME WHERE ARE WE IN TIME WHERE ARE
WE IN TIME WHERE ARE WE IN TIME WHERE ARE WE IN TIME
WHERE ARE WE IN TIME WHERE ARE WE IN TIME WHERE ARE
WE IN TIME WHERE ARE WE IN TIME WHERE ARE WE IN TIME
WHERE ARE WE IN TIME WHERE ARE WE IN TIME WHERE ARE
WE IN TIME WHERE ARE WE IN TIME WHERE ARE WE IN TIME
WHERE ARE WE IN TIME WHERE ARE WE IN TIME WHERE ARE
WE IN TIME WHERE ARE WE IN TIME WHERE ARE WE IN TIME
WHERE ARE WE IN TIME WHERE ARE WE IN TIME WHERE ARE
WE IN TIME WHERE ARE WE IN TIME WHERE ARE WE IN TIME
WHERE ARE WE IN TIME WHERE ARE WE IN TIME WHERE ARE
WE IN TIME WHERE ARE WE IN TIME WHERE ARE WE IN TIME
WHERE ARE WE IN TIME WHERE ARE WE IN TIME WHERE ARE
WE IN TIME WHERE ARE WE IN TIME WHERE ARE WE IN TIME
WHERE ARE WE IN TIME WHERE ARE WE IN TIME WHERE ARE
WE IN TIME WHERE ARE WE IN TIME WHERE ARE WE IN TIME
WHERE ARE WE IN TIME WHERE ARE WE IN TIME WHERE ARE
WE IN TIME WHERE ARE WE IN TIME WHERE ARE WE IN TIME
WHERE ARE WE IN TIME WHERE ARE WE IN TIME WHERE ARE
WE IN TIME WHERE ARE WE IN TIME WHERE ARE WE IN TIME
WHERE ARE WE IN TIME WHERE ARE WE IN TIME WHERE ARE
WE IN TIME WHERE ARE WE IN TIME WHERE ARE WE IN TIME
WHERE ARE WE IN TIME WHERE ARE WE IN TIME WHERE ARE
WE IN TIME WHERE ARE WE IN TIME WHERE ARE WE IN TIME
WHERE ARE WE IN TIME WHERE ARE WE IN TIME WHERE ARE
WE IN TIME WHERE ARE WE IN TIME WHERE ARE WE IN TIME

WHERE ARE WE IN TIME WHERE ARE WE IN TIME WHERE ARE
WE IN TIME WHERE ARE WE IN TIME WHERE ARE WE IN TIME
WHERE ARE WE IN TIME WHERE ARE WE IN TIME WHERE ARE
WE IN TIME WHERE ARE WE IN TIME WHERE ARE WE IN TIME
WHERE ARE WE IN TIME WHERE ARE WE IN TIME WHERE ARE
WE IN TIME WHERE ARE WE IN TIME WHERE ARE WE IN TIME
WHERE ARE WE IN TIME WHERE ARE WE IN TIME WHERE ARE
WE IN TIME WHERE ARE WE IN TIME WHERE ARE WE IN TIME
WHERE ARE WE IN TIME WHERE ARE WE IN TIME WHERE ARE
WE IN TIME WHERE ARE WE IN TIME WHERE ARE WE IN TIME
WHERE ARE WE IN TIME WHERE ARE WE IN TIME WHERE ARE
WE IN TIME WHERE ARE WE IN TIME WHERE ARE WE IN TIME
WHERE ARE WE IN TIME WHERE ARE WE IN TIME WHERE ARE
WE IN TIME WHERE ARE WE IN TIME WHERE ARE WE IN TIME
WHERE ARE WE IN TIME WHERE ARE WE IN TIME WHERE ARE
WE IN TIME WHERE ARE WE IN TIME WHERE ARE WE IN TIME
WHERE ARE WE IN TIME WHERE ARE WE IN TIME WHERE ARE
WE IN TIME WHERE ARE WE IN TIME WHERE ARE WE IN TIME
WHERE ARE WE IN TIME WHERE ARE WE IN TIME WHERE ARE
WE IN TIME WHERE ARE WE IN TIME WHERE ARE WE IN TIME
WHERE ARE WE IN TIME WHERE ARE WE IN TIME WHERE ARE
WE IN TIME WHERE ARE WE IN TIME WHERE ARE WE IN TIME
WHERE ARE WE IN TIME WHERE ARE WE IN TIME WHERE ARE
WE IN TIME WHERE ARE WE IN TIME WHERE ARE WE IN TIME
WHERE ARE WE IN TIME WHERE ARE WE IN TIME WHERE ARE
WE IN TIME WHERE ARE WE IN TIME WHERE ARE WE IN TIME
WHERE ARE WE IN TIME WHERE ARE WE IN TIME WHERE ARE
WE IN TIME WHERE ARE WE IN TIME WHERE ARE WE IN TIME
WHERE ARE WE IN TIME WHERE ARE WE IN TIME WHERE ARE
WE IN TIME WHERE ARE WE IN TIME WHERE ARE WE IN TIME
WHERE ARE WE IN TIME WHERE ARE WE IN TIME WHERE ARE
WE IN TIME WHERE ARE WE IN TIME WHERE ARE WE IN TIME
WHERE ARE WE IN TIME WHERE ARE WE IN TIME WHERE ARE
WE IN TIME WHERE ARE WE IN TIME WHERE ARE WE IN TIME
WHERE ARE WE IN TIME WHERE ARE WE IN TIME WHERE ARE
WE IN TIME WHERE ARE WE IN TIME WHERE ARE WE IN TIME

Time is such a nuisance
It's always "running out"
We dream to somehow freeze it
And stop its forward route

Time is such a bother
We never have enough
Once the hands start ticking
We cannot stop the clock

Trapped in passing minutes
Numbers that confine
The tightest grip
They seem to have

These ticking hands of time

It measures up our moments
The hours come and gone
A reminder that we're finite
While it rushes us along

Time can flow by slowly
Though we mostly seem to race it
Either way, it's here to stay

No matter how we face it.

There is so much to say about time. It teaches us. Heals us. Sets us free.

Time is the most precious gift. It is the only thing we never seem to have enough of, so when we give it to someone or something it truly shows what we value. *You cannot get back the time you give.*

Time is the most precious of all things—yet we cannot grasp it. We can only let it tick by and somehow try to find a way to not let it trap us.

Oh, time. We always seem to know where are within it. We always seem let it get away from us. We try to race it. Outrun it. Beat the clock. Like fate, time is clever. Quick. It seems to only move in one direction as an unstoppable, invisible force. Yet, we find a way to dance between the realms of time: past and future. We travel back with our memories and forward with our hopes and worries. We are continuously learning through time from time. The past creates our future. The present sets us free.

We always seem to forget that if we're still—*so is time.* Staying present in the moment is the secret weapon to mastering the ever flowing river of time itself. The present is the only occasion where time is non-existent and infinite all at once. When we master the present, the past cannot dwell and the future cannot linger before us.

When we remain in the moment, time stops. It becomes nothing but numbers and cogs. It cannot bind us. It ceases to have a forward or back.

It just is.

Once you learn to flow freely from past to present, you discover that time is not an enemy—it is the greatest teacher of them all. When you allow the past to be the sturdy bricks of the foundation on which you're built then you will stand tall and strong like a lighthouse. Your light, not to be swayed by minutes and hours but only guided by the number on which the hands of time tick past.

So, where are we in time?

We're here and now.

Ask Yourself,

Where are you in this exact moment?

How do you feel?

Take a look around you.

What do you see?

Are there people? Is the sun sitting peacefully in the sky above your head with the clouds dancing merrily around it? Is the sky clear and brilliantly blue? Is it cold? Is it warm? Is the sun beating down on your shoulders or is the wind rustling your hair? Are there birds? Are you inside? Outside? Sitting or standing? Maybe you're laying down. Are you on a train? In a chair? Surrounded by four walls? Next to a window? Wherever you are, whatever is happening around you, right now, **this is your new present.**

What are you going to do with it?

Are you going to be an object at rest or an object in motion?

Where do you stand within duality, reality, and mentality?

MENTALITY DUALITY REALITY MENTALITY DUALITY REALITY
MENTALITY DUALITY REALITY MENTALITY DUALITY REALITY
MENTALITY DUALITY REALITY MENTALITY DUALITY REALITY
MENTALITY DUALITY REALITY MENTALITY DUALITY REALITY
MENTALITY DUALITY REALITY MENTALITY DUALITY REALITY
MENTALITY DUALITY REALITY MENTALITY DUALITY REALITY
MENTALITY DUALITY REALITY MENTALITY DUALITY REALITY
MENTALITY DUALITY REALITY MENTALITY DUALITY REALITY
MENTALITY DUALITY REALITY MENTALITY DUALITY REALITY
MENTALITY DUALITY REALITY MENTALITY DUALITY REALITY
MENTALITY DUALITY REALITY MENTALITY DUALITY REALITY
MENTALITY DUALITY REALITY MENTALITY DUALITY REALITY
MENTALITY DUALITY REALITY MENTALITY DUALITY REALITY
MENTALITY DUALITY REALITY MENTALITY DUALITY REALITY
MENTALITY DUALITY REALITY MENTALITY DUALITY REALITY
MENTALITY DUALITY REALITY MENTALITY DUALITY REALITY
MENTALITY DUALITY REALITY MENTALITY DUALITY REALITY
MENTALITY DUALITY REALITY MENTALITY DUALITY REALITY
MENTALITY DUALITY REALITY MENTALITY DUALITY REALITY
MENTALITY DUALITY REALITY MENTALITY DUALITY REALITY
MENTALITY DUALITY REALITY MENTALITY DUALITY REALITY
MENTALITY DUALITY REALITY MENTALITY DUALITY REALITY
MENTALITY DUALITY REALITY MENTALITY DUALITY REALITY
MENTALITY DUALITY REALITY MENTALITY DUALITY REALITY
MENTALITY DUALITY REALITY MENTALITY DUALITY REALITY
MENTALITY DUALITY REALITY MENTALITY DUALITY REALITY
MENTALITY DUALITY REALITY MENTALITY DUALITY REALITY
MENTALITY DUALITY REALITY MENTALITY DUALITY REALITY
MENTALITY DUALITY REALITY MENTALITY DUALITY REALITY
MENTALITY DUALITY REALITY MENTALITY DUALITY REALITY
MENTALITY DUALITY REALITY MENTALITY DUALITY REALITY
MENTALITY DUALITY REALITY MENTALITY DUALITY REALITY
MENTALITY DUALITY REALITY MENTALITY DUALITY REALITY
MENTALITY DUALITY REALITY MENTALITY DUALITY REALITY
MENTALITY DUALITY REALITY MENTALITY DUALITY REALITY
MENTALITY DUALITY REALITY MENTALITY DUALITY REALITY

MENTALITY DUALITY REALITY MENTALITY DUALITY REALITY
MENTALITY DUALITY REALITY MENTALITY DUALITY REALITY
MENTALITY DUALITY REALITY MENTALITY DUALITY REALITY
MENTALITY DUALITY REALITY MENTALITY DUALITY REALITY
MENTALITY DUALITY REALITY MENTALITY DUALITY REALITY
MENTALITY DUALITY REALITY MENTALITY DUALITY REALITY
MENTALITY DUALITY REALITY MENTALITY DUALITY REALITY
MENTALITY DUALITY REALITY MENTALITY DUALITY REALITY
MENTALITY DUALITY REALITY MENTALITY DUALITY REALITY
MENTALITY DUALITY REALITY MENTALITY DUALITY REALITY
MENTALITY DUALITY REALITY MENTALITY DUALITY REALITY
MENTALITY DUALITY REALITY MENTALITY DUALITY REALITY
MENTALITY DUALITY REALITY MENTALITY DUALITY REALITY
MENTALITY DUALITY REALITY MENTALITY DUALITY REALITY
MENTALITY DUALITY REALITY MENTALITY DUALITY REALITY
MENTALITY DUALITY REALITY MENTALITY DUALITY REALITY
MENTALITY DUALITY REALITY MENTALITY DUALITY REALITY
MENTALITY DUALITY REALITY MENTALITY DUALITY REALITY
MENTALITY DUALITY REALITY MENTALITY DUALITY REALITY
MENTALITY DUALITY REALITY MENTALITY DUALITY REALITY
MENTALITY DUALITY REALITY MENTALITY DUALITY REALITY
MENTALITY DUALITY REALITY MENTALITY DUALITY REALITY
MENTALITY DUALITY REALITY MENTALITY DUALITY REALITY
MENTALITY DUALITY REALITY MENTALITY DUALITY REALITY
MENTALITY DUALITY REALITY MENTALITY DUALITY REALITY
MENTALITY DUALITY REALITY MENTALITY DUALITY REALITY
MENTALITY DUALITY REALITY MENTALITY DUALITY REALITY
MENTALITY DUALITY REALITY MENTALITY DUALITY REALITY
MENTALITY DUALITY REALITY MENTALITY DUALITY REALITY
MENTALITY DUALITY REALITY MENTALITY DUALITY REALITY
MENTALITY DUALITY REALITY MENTALITY DUALITY REALITY
MENTALITY DUALITY REALITY MENTALITY DUALITY REALITY
MENTALITY DUALITY REALITY MENTALITY DUALITY REALITY
MENTALITY DUALITY REALITY MENTALITY DUALITY REALITY
MENTALITY DUALITY REALITY MENTALITY DUALITY REALITY

Picture this...

You shake hands with reality and the battle begins.

It's really good at throwing punches and most of them you don't see coming.

But you keep fighting.

Every time reality knocks you off your feet, you get back up again.

You can hear the crowd hollering in the stands. Beads of sweat and blood drip down your face. You can see the timer running behind you. Time is ticking, ticking, ticking and you're getting nowhere. Reality keeps throwing punches and you can't seem to avoid them.

Then, you realize something.

Reality hates to be accepted.

So, you stop fighting back.

You stand in place for a moment and let reality wind up for its next big punch.

You wait a minute...and nothing.

It's confused. It doesn't know why you're not fighting back. It doesn't know why you're so calm. So balanced. So...*collected.*

Reality lets its guard down.

Then, you take your shot.

One punch...

You win.

Dear Reader,

It is not about making peace with the past, it is about making peace with the present as a result of the past. You must accept that the future is forever unknown, because whatever happens next is simply the aftermath of all unrest—an uncontrollable outcome of cause and effect.

What does one do when the battle of the mind meets the battle with reality?

You accept it for what it is and you move forward. You continue despite the hardship, knowing eventually, it will all fall beautifully into place. You have to go in the direction of hope and hang on to the fact that one day everything will be okay. It will soon make sense but you have to see it through.

Ex Malo Bonum ~ out of bad comes good.

Always believe in yourself, in the world, and in the power of good.

Go forth and be great. **I believe in you.**

Until we meet again,

Natalie

Natalie Nascenzi

Hi Everyone!

I'm Nat and I'm a poet, author, and copywriter. I'm originally from Rhode Island and I currently live in Manhattan, New York City. You might already know me from my first book, *Out Of Chaos*. Truthfully, I don't find it fitting to describe myself. I think you can you find all that juicy information somewhere on the internet. Instead, here's a poem:

Behind me, a flock of reflections

All variations of *me*
These shells of my past, build a shield
Near impossible to defeat

A vessel of oneness, abundance, and radiance

No longer ruled by duality
My balanced body, a collection of selves

The champion of unknown reality.

The freest of birds
The ringleader
A river, that endlessly flows
Heart of a butterfly
Soul of a warrior

I am the very last rose.

Follow me: @nncenzi

Grant McGrath

Beyond The Character

Originally from the San Francisco Bay Area, Grant moved to New York City in 2012 to persue a career as an Artist. He has spent the past eight years practicing his craft primarily from his Green Point studio.

Painting is his primary form of artistic expression, but he dabbles with every art form. With Grant, you can expect the unexpected. He's constantly exploring a range of styles and mediums and considers himself, "the consistently inconsistent artist." From abstract to realism to impressionism and back again—Grant switches up his style seamlessly. His work is regularly exhibited in New York City and Brooklyn.

When he's not in his studio, you may catch Grant sketching around the city, contemplating his next creation, perfecting his old English accent, or riding his lovely blue bike "Azula."

Keep an eye out for the guy in red shoes and ever-changing handlebars—it's probably Grant.

Follow Grant on Instagram:

@grantmcgrath.art

Nicolle DiIorio

2 L's Are Better Than 1

Nicolle is originally from Long Island, New York but moved to Manhattan in 2013. Since then, she's worked as an Art Director and more recently began tapping back into her roots as an artist.

This year, she started exploring different art styles and mediums.

This led to the creation of her Instagram @draw_by_dip.

Nicolle's greatest joy artistically is capturing moments through her drawings. Now, she's found a way to merge her passion for the arts *and* making people smile by creating one-of-a-kind pieces in all mediums.

When she's not doing art, you can find Nicolle roller blading in the city, messing around with musical instruments or experimenting with random pantry items. The on-going list includes: homemade alcoholic jams, ice cream, kombucha, pickles, and yes, she too had a bread phase.

To check out more of her recent works, follow her on Instagram:

@draw_by_dip.

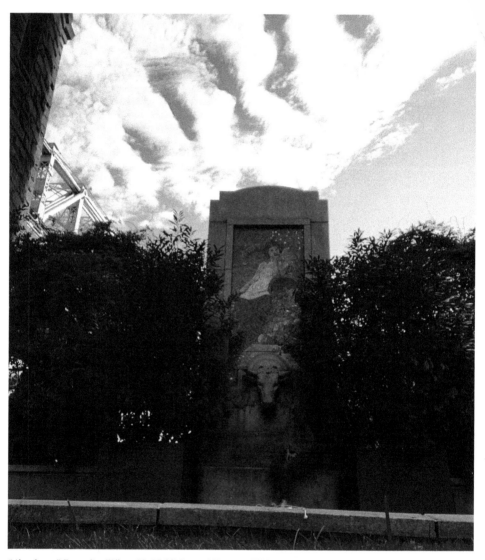

"Abundance," Evangeline Wilbour Blashfield Memorial Fountain, 2020.

Evangeline Wilbour Blashfield

Forever in Time

Evangeline Wilbour Blashfield was born on September 1, 1858 in Little Compton, Rhode Island. She grew up in New York City and spent most of her childhood summering in Rhode Island. She was known as a pioneering feminist, intellectual, and historian. Evangeline was a remarkable woman of her time. She was fluent in French and Italian, and proficient in German, Arabic, and Latin. Evangeline was an expert on art history, literature, and theatre. She authored dozens of books, articles, and speeches on art, history, urban planning, theatre, literature, and the history of women.

In 1876 at a dance in Paris, Evangeline met Edwin Howland Blashfield, a young impressionist painter. The couple married in 1881 and moved to New York City. Together they published one of the most famous books on art and architecture: *Italian Cities*. They also produced many collections of published works over the years.

In 1918, at the age of 59, Evangeline passed away from complications of Spanish Influenza. Her legacy was carried on by her husband, who helped erect "Abundance," the Evangeline Wilbour Blashfield Memorial fountain at Bridgemarket, underneath the Queensborough Bridge (a.k.a The Rose Park).

You know the drill. I never forget a soul who touches mine and there is always a list of people. This list consists of those who have inspired me or played a role in my life during the writing of this book.

Brandon Flores

Cameron Edwards

Christian Clark

Diana Rofail

Donavan McNeil (Macadon Blackheart)

Gene & Mary Jane Detroyer

Isabel Gross

Joe Schinco

Kerry

Lorianna Logan

Manuel Acciemius

Morgan Chudik

Norman Drakeford

Nick Beck

Tonii (Anthony Langhorne)

My neighbors: Nellie, Mike & Leila, Chick & Barbara, Martie, Billy, Stan, and Serge

Visit The Greats of Craft: www.greatsofcraft.com, @thegreatsofcraft

Discover ii Publishing: @iipublishing

Find me on Instagram: @nncenzi

Special thank you to The Greats of Craft

On the corner of 54th and 1st sits a small coffee shop/bar. At first glance, it seems like any other place on the street. Trust me when I say, there's something magical about The Greats of Craft. If you ever have a chance to stop by, I highly recommend the raisin scone or one of their local craft brews! I'd like to believe that it was fate that kept it open during the pandemic, but either way, I'm forever grateful for this place and all of the people it has allowed me to cross paths with.

During quarantine, it was one of the only places to remain open in my neighborhood. It was the tiniest sliver of normalcy and the greatest blessing. If it wasn't for my morning chats with Joe and Brandon I most definitely wouldn't have stayed sane during the pandemic. They were the only people I could interact with (besides my roommate and neighbors) and it became the best part of my day. But it's not just having them there during those harrowing months that makes this place so special. It's what happened once New York City began to reopen.

Joe and his family are wonderful people. Most importantly, they care. Joe is always thinking of ways to make The Greats of Craft feel welcoming and open. Due to the new rules of the pandemic, they installed windows that opened up the walls and allowed for seating on the sidewalk. This made the perfect set-up for working outside. It had been long few months stuck indoors and I *needed* a place to work and write.

Low and behold, 'GOC' is where I ended up. I worked there all day, everyday during the summer months as New York City began reopening. I finished this book there, worked my 9-5 and met so many wonderful people. The open seating meant being able to say hello to passing strangers and, of course, dozens of neighborhood dogs! Everyone who came and passed became a familiar face and a few even became some of my greatest friends. GOC brought us together and gave us all somewhere to be in the midst of the madness. In the end, it became home to a collection of strangers that were at one point just random passing souls on New York City streets—*and that right there is a beautiful thing.*

Thank you to Joe and his family, Brandon, and Nick!
Thank you to the GOC Family.

Reality
Duality
Mentality
When you face it, you will learn
The mirror, then, will smile back
And, inner peace *returns*

Sureness floods the iris
Ever flowing clarity
Two selves, entwine
And then, align
The fusion of polarity

Divergence now similarity
The past a wise, old friend
The grand design of bending time
Allows the mind to mend

We understand

Every obstacle we overcome
A mission to make us stronger
Although it leaves us broken
We rise
Rebuild
And conquer.

Reality, duality, mentality
Trust me, you can win
All it takes is inner strength
In other words:

Rule From Within

CPSIA information can be obtained
at www.ICGtesting.com
Printed in the USA
LVHW020108151120
671611LV00011B/582

9 780578 777665